Mountains
of the Coast

MOUNTAINS

PHOTOGRAPHS OF REMOTE CORNERS OF THE COAST MOUNTAINS

BY JOHN BALDWIN

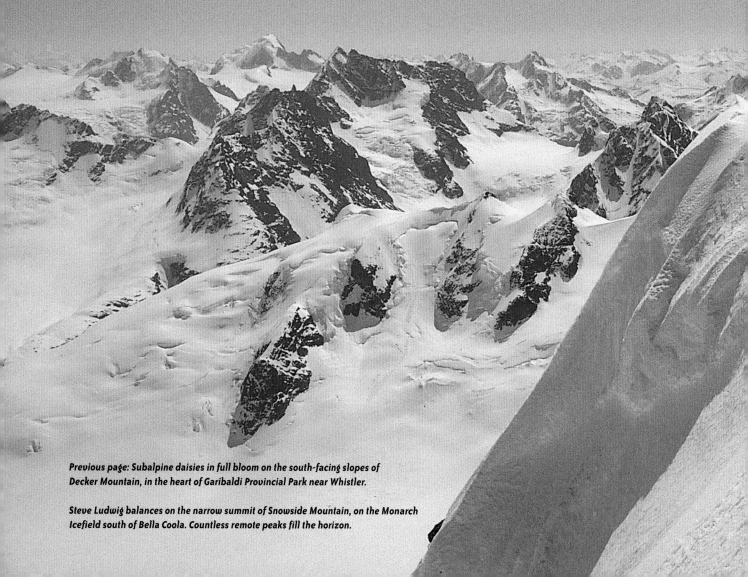

Previous page: Subalpine daisies in full bloom on the south-facing slopes of Decker Mountain, in the heart of Garibaldi Provincial Park near Whistler.

Steve Ludwig balances on the narrow summit of Snowside Mountain, on the Monarch Icefield south of Bella Coola. Countless remote peaks fill the horizon.

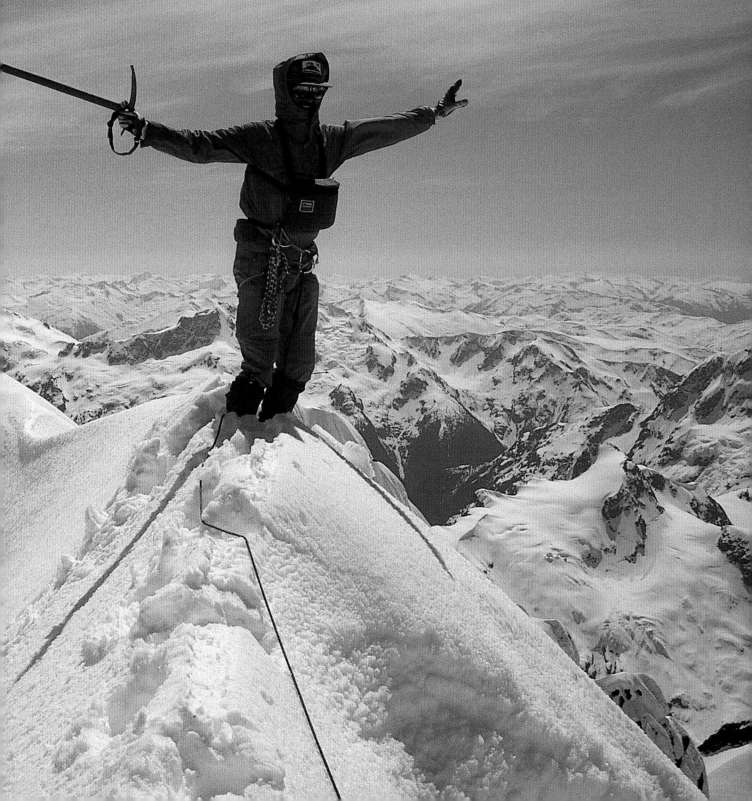

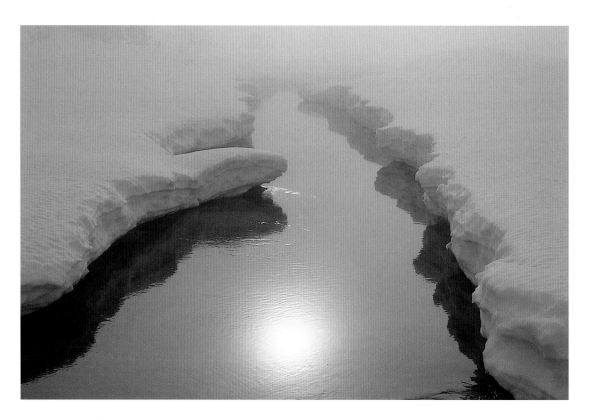

To my father
 who showed me how to explore,
and to my mother
 who taught me to see beauty in unexpected things.

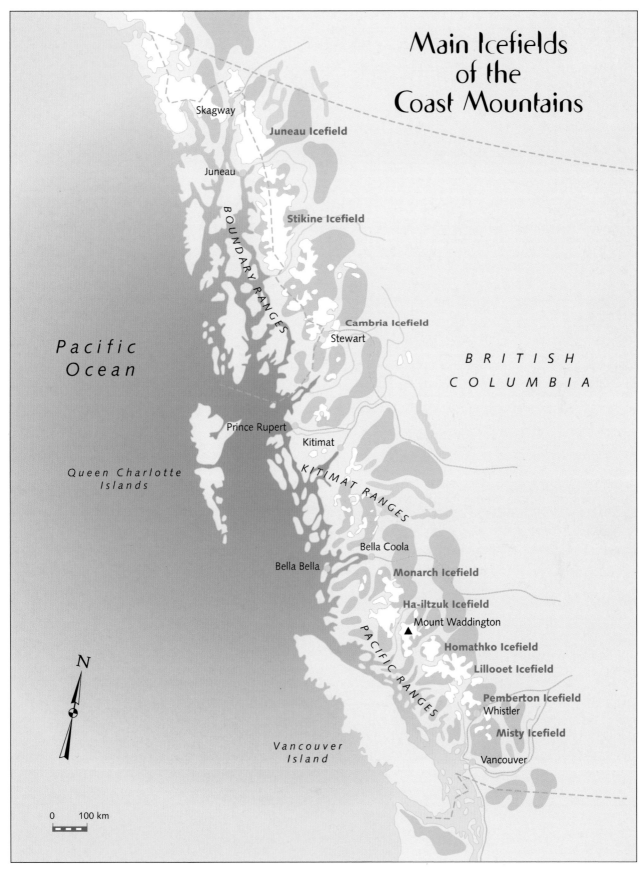

Main Icefields of the Coast Mountains

Skagway

Juneau Icefield

Juneau

BOUNDARY RANGES

Stikine Icefield

Cambria Icefield

Stewart

Pacific Ocean

B R I T I S H
C O L U M B I A

Prince Rupert

Kitimat

KITIMAT RANGES

Queen Charlotte Islands

Bella Coola

Bella Bella

Monarch Icefield

Ha-iltzuk Icefield

▲ Mount Waddington

Homathko Icefield

PACIFIC RANGES

Lillooet Icefield

Pemberton Icefield

Whistler

Misty Icefield

Vancouver

Vancouver Island

N

0 100 km

5 M

ACKNOWLEDGEMENTS

Climbing mountains is generally not something you do alone and I would like to thank
all the people whom I have accompanied into the mountains over the years, including
Steve Ludwig, Helen Sovdat, George Fulton and especially John Clarke.
I would also like to thank Howard White and everyone at Harbour Publishing for their interest
in my proposal for this book and for making it happen.
And a special thanks to my wife Eda Kadar for her help with the manuscript.

CONTENTS

Canada's third largest city is perhaps best known for its rain but equally ingrained into the consciousness of every Vancouverite are the mountains that rise above the flanks of the city and stretch northward for 1,500 kilometres to Alaska.

INTRODUCTION

These are the Coast Mountains. They are the last in a series of mountain ranges between the Rockies and the Pacific Ocean and form the first major barrier to winter storms sweeping off the Pacific. If one word were used to describe these mountains it would without a doubt be "wet." Their toes sit right in the ocean, and like the barnacles in the surf below they are constantly lashed with moisture from the sea. This moisture gives the Coast Mountains an incredible richness, sustaining large icefields in close proximity to lush rain forests. For many people the Coast Mountains are a symbol of the great wilds of BC and a scenic splendour to be admired from a distance. For me they are part of my backyard, and the wish to discover what lies beyond these mountains that form the backdrop of my daily life has been my lifelong passion. The purpose of this book is to give the reader an impression of this vast, magnificent range of mountains. I took the photographs in this book while on extended mountaineering trips into far corners of the Coast Mountains during the past twenty years. Many of these areas have seldom if ever been seen before, and the images here offer the first detailed portrait of the remoter parts of the Coast Mountains ever published.

The south face of the north-west peak of Mt. Waddington after a spring snowstorm.

Inset, opposite: The wet climate of the west coast sustains large glaciers in close proximity to lush rain forests, but the extensive glaciation of the Coast Mountains is rarely visible from valley bottoms. Views of glaciers like this one above the Homathko River are often the only hint of the vast icefields that lie above.

Inset, below: John Clarke admires a view of Bute Inlet. Many such fjords wind their way 60–80 kilometres into the Coast Mountains.

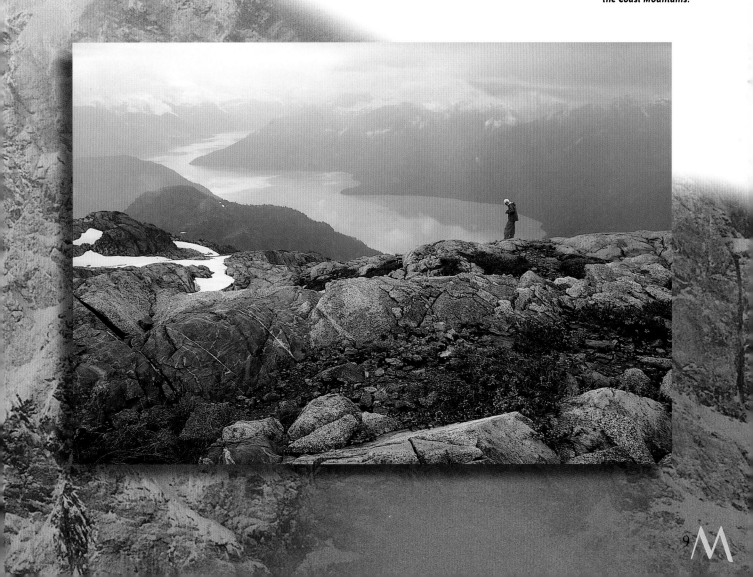

The western edge of British Columbia is a green mosaic of cone-shaped hills and long, dark channels. Hidden in the mists beyond the heads of these inlets lie the Coast Mountains. Generally snowy and rugged, they begin as low forested hills whose dark green slopes rise up from the sea. The mountains are cut by deep glacially carved valleys and long fjords. Summits near the coast are steep, rounded and heavily forested and there is little extensive alpine area. The mountains on the north shore of Vancouver and rimming the Strait of Georgia are typical of these. Inland at the heads of the long fjords, higher summits reach above treeline. Beyond this lies the backbone of the range, where the mountains are draped in snow year-round and are surrounded by large icefields. Glaciation is widespread, in some regions engulfing all but the highest peaks. East of the main divide the mountains tend to be more barren and gentle in appearance as they fade into the interior plateau. Glaciation is lighter and the deep coastal drainages give way to broad subalpine valleys and alpine meadows.

Most summits rise to between 2,500 and 3,200 metres, with the highest summit in the range, Mt. Waddington, rising to just over 4,000 metres. Treeline is typically near 1,500 metres but much of the range is extremely alpine due to extensive glaciation.

The climate is marked by wet, relatively mild winters and cool, cloudy summers with an annual precipitation of well over 3 metres in the mountainous areas. The bulk of the precipitation occurs between October and April, most of it falling as snow at higher elevations, so that an annual snowpack of over 5 metres is not uncommon in the alpine. It is this tremendous snowfall that sustains the extensive glaciation that makes the Coast Mountains one of the most heavily glaciated subpolar mountain ranges on earth. In some regions remnants of the vast ice sheets of the last ice age, up to 1,000 square kilometres, cover all but the highest peaks and are drained by glaciers up to 50 kilometres long. Glaciers commonly extend to below an elevation of 1,000 metres with a few of the larger valley glaciers reaching as low as 200 metres above sea level. In the Waddington region, glaciation spans an elevation difference of 3,600 metres—comparable to some of the highest mountain ranges on earth.

Far right: The Coast Mountains are one of the most heavily glaciated mountain ranges on earth, outside of the polar regions. Glaciers such as these tumbling from 2,500-metre peaks above Stanton Creek are typical of most areas in the Coast Mountains. This fact is rarely appreciated even though glaciers lie within commuting distance of downtown Vancouver.

Right: Heavily forested slopes at the outer edge of the Coast Mountains rise directly from the sea in a view from Mt. Whieldon overlooking East Redonda Island and Homfray Channel in Desolation Sound, a popular getaway spot.

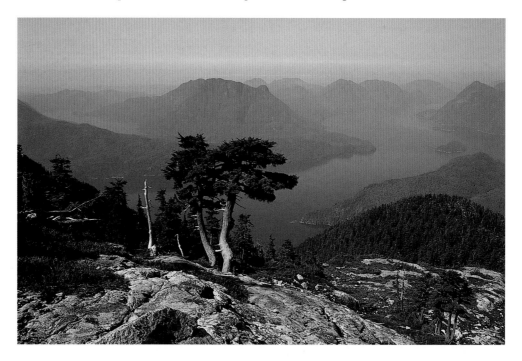

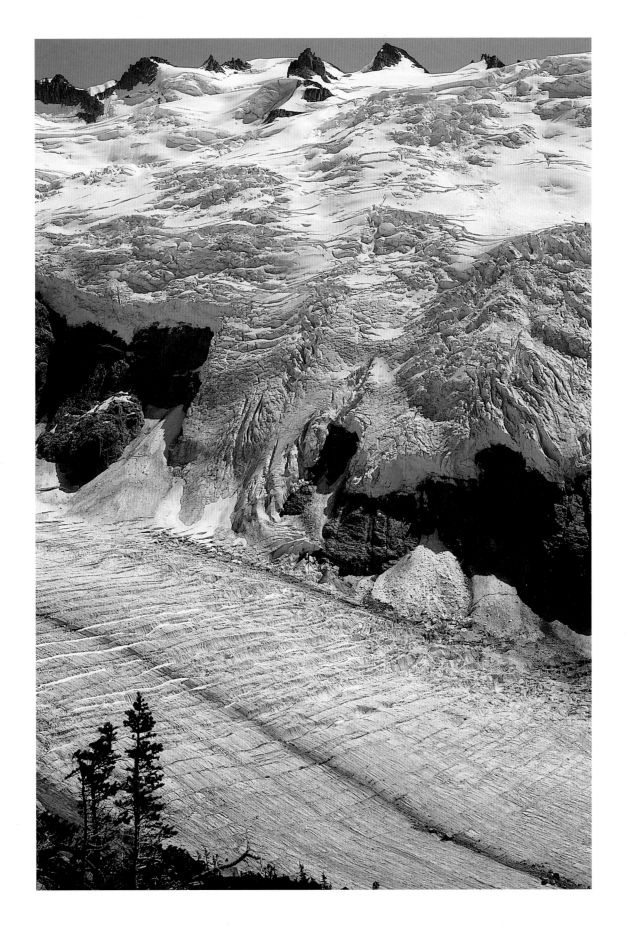

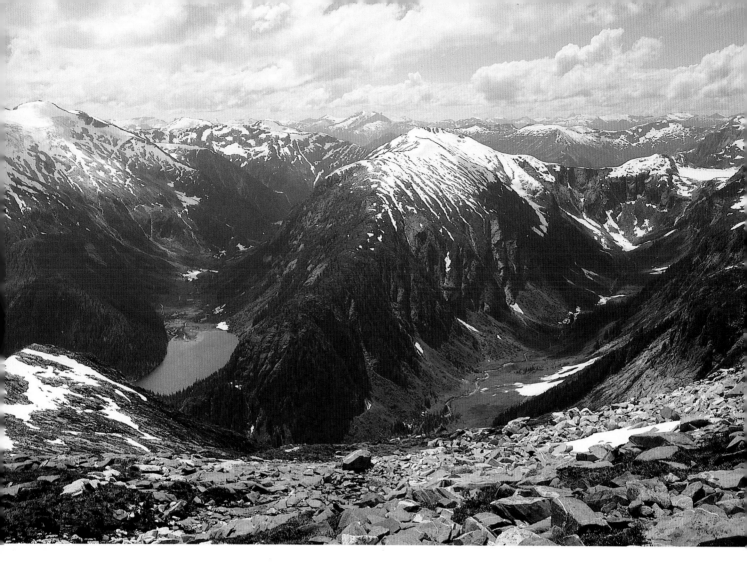

The headwaters of the Inziana River illustrate the deep U-shaped valleys carved out by the glacial advances of the ice age, when all but the highest summits were covered by ice.

Equally striking is the variation in climate with elevation. Despite the heavy snowfall in the mountains, areas at sea level rarely receive snow and the differences between sea level and the mountaintops are pronounced: in May, swimming in the ocean takes place within 10 kilometres of skiing in the alpine.

Geologically speaking, the Coast Mountains are considerably younger than the Rocky Mountains and other interior ranges. As the earth's crust was forced beneath the edge of the North American continent over the last 50 to 150 million years in a process called subduction, the heat generated molten rock, or magma, deep below the earth's surface, forming the Coast Plutonic Complex, one of the world's largest masses of granitic rocks. This complex consists predominantly of plutonic rock of various ages, but includes some volcanic and sedimentary rocks that were mixed and altered with the granitic magma. The Coast Mountains are generally thought to have been formed within the last 20 million years, when this complex was uplifted by the stresses associated with continental drift.

The ruggedness of the Coast Mountains was further accentuated by the glacial advances of the last ice age during the period from 1 to 2 million years ago to about 10,000 years ago. All but the highest summits in the eastern part of the range were covered by ice, and the glaciers carved out deep U-shaped valleys and steepened alpine cirques (bowl-shaped hollows). As the ice retreated, large icefields remained in the alpine as remnants of the vast ice sheets and the deep coastal valleys were left flanked by miles of cliff and slab.

The above description does little to portray the wilderness character of the Coast Mountains. Roads cross this range only four times along its entire 1,500 kilometres of length, and the intervening sections are roadless. There are no trails in the deep coastal valleys, and the more remote summits lie amidst large icefields, miles from the nearest valley. Limited access is by far the greatest obstacle to climbing in the Coast Mountains. Travel is slow and strenuous through dense undergrowth, past mazes of crevasses and across large icefields in often poor weather. Roughly three times the size of the Sierra Nevada or the European Alps, the Coast Mountains see fewer climbers in an entire year than the Alps or the Sierras do in a busy weekend. Few mountain regions, except Antarctica and the far north, can offer the same degree of pristine wilderness as the Coast Mountains. In many areas only the major rivers have names, and in the more remote sections it may be safe to say that the goats living high in the mountains are not yet aware that the white man has come to North America. In most low-lying areas the high alpine peaks and extensive glaciation are rarely visible, and this fact dominates the history of the Coast Mountains. Abundant sea life on the west coast supported a sizable Native population. Though trading routes through the mountains were well established and occasional hunting forays were made into the mountains, it is doubtful that the Natives ventured much onto the higher icy summits. Likewise the rugged nature of the high alpine areas forced early explorers, trappers and prospectors to spend most of their time in the valleys, and exploration of these high mountains was left for future mountaineers.

Mountain goats are the only large animals seen in the alpine regions of the Coast Mountains.

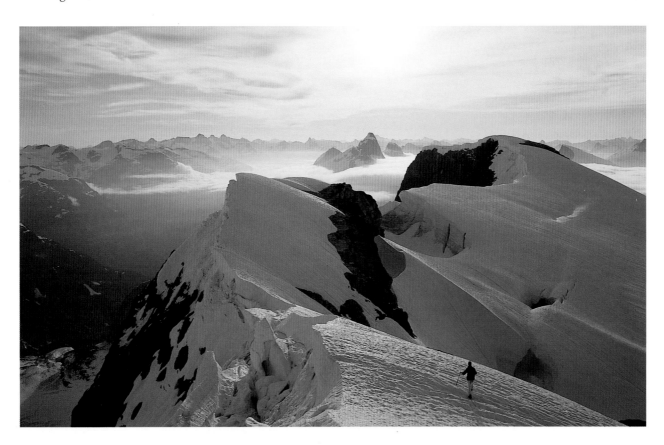

Rugged alpine terrain, such as the peaks beyond the head of Toba Inlet shown here, prevented much early exploration in the Coast Mountains.

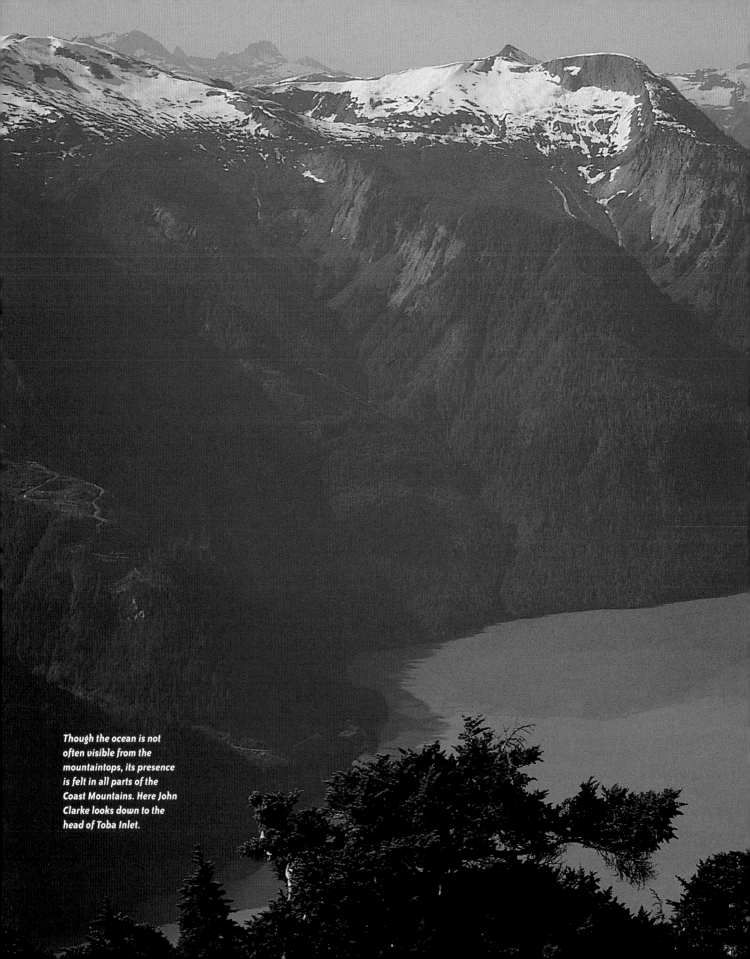

Though the ocean is not often visible from the mountaintops, its presence is felt in all parts of the Coast Mountains. Here John Clarke looks down to the head of Toba Inlet.

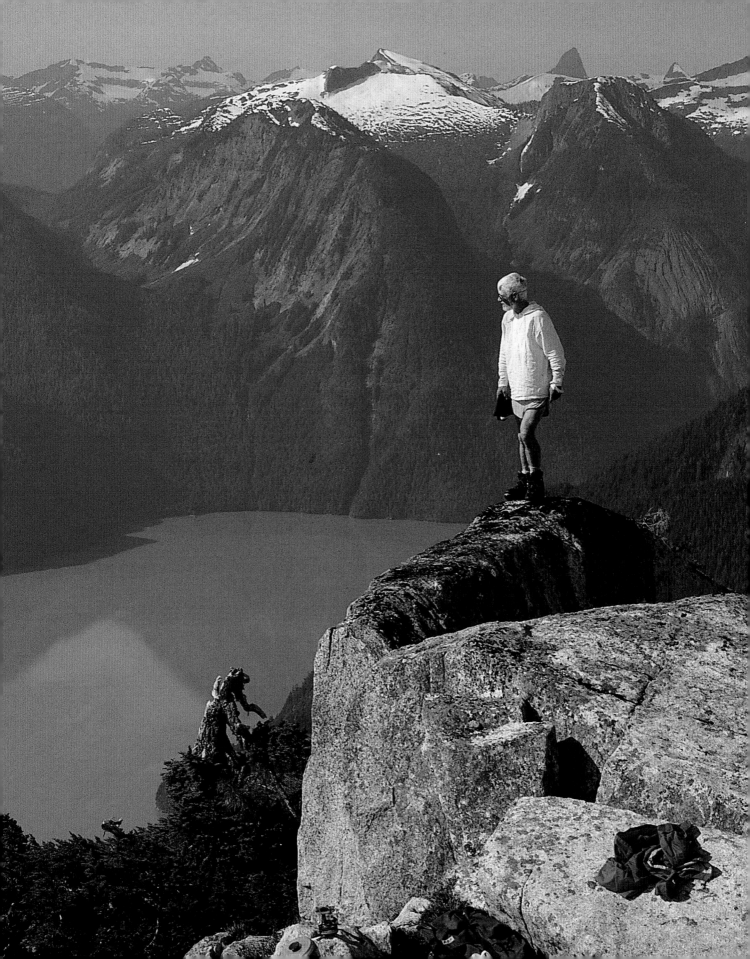

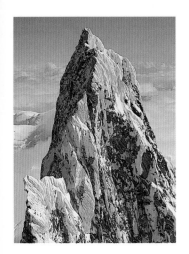

Above: This classic view of the main summit of Mt. Waddington from the northwest peak was first seen in 1928. It inspired newspaper headlines like "Can Mt. Waddington be climbed?"

Below: John Clarke gazes at the Waddington Range rising in the distance above the mist-filled valley of the Homathko River.

The mountains above Vancouver were some of the first to be climbed in the Coast Mountains. One of the earliest recorded ascents is a climb of the West Lion in 1899. As the fledgling city of Vancouver grew, so too did an interest in mountaineering, and by the early 1900s regular ascents were being made of the local mountains north of Vancouver. The ascent of Mt. Garibaldi in 1907 marked the first climb of a truly alpine peak in the area. Despite this and subsequent ascents of other alpine summits in what was later to become Garibaldi Provincial Park, there remained a belief that most of the Coast Mountains were similar to the heavily forested slopes that can be seen from the sea. So entrenched was this idea that the first reports of high icy summits in the 1920s were not believed. It was at this time that Mt. Waddington was discovered. At 4,019 metres Mt. Waddington is the highest summit in provincial Canada, but only after considerable challenge was it finally acknowledged that the Coast Mountains contained a summit higher than any in the Canadian Rockies.

The discovery of Mt. Waddington as the apex of a vast range of mountains containing some of the most rugged glaciated summits in North America ushered in the golden age of mountaineering in the Coast Mountains. Attention was immediately focussed on Mt. Waddington, led by a young Vancouver couple, Don and Phyllis Munday, who had first been drawn to the mountain in 1925 by distant views of high icy summits from Vancouver Island. The Mundays spent a total of nine seasons in the Mt. Waddington area reaching the northwest peak of the mountain, but the difficulties of the slightly higher tower of the main summit prompted newspaper headlines like "Can Mt. Waddington be climbed?" Such coverage drew the attention of international climbers, and after many attempts the mountain was finally climbed in 1936. This period of mountaineering in the Coast Mountains was characterized by arduous relaying of supplies up bushy coastal valleys and difficult approaches up long glaciers. These challenges were compounded by a lack of knowledge about the geography of the mountains and in many cases the climbers themselves made the first maps, pieced together from summit photographs. Generally the highest summits were climbed first, but exploration was a slow process and even by the 1950s there were large areas in which not a single mountain had been climbed.

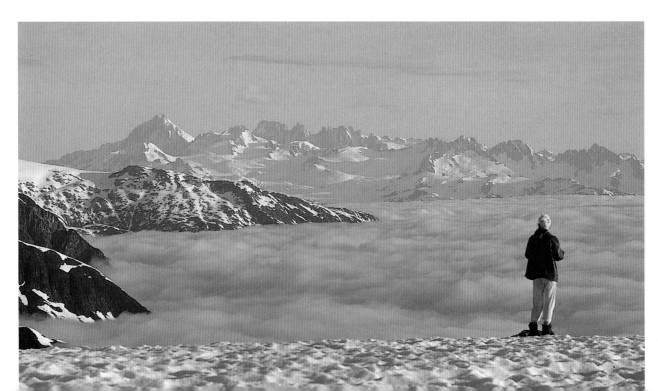

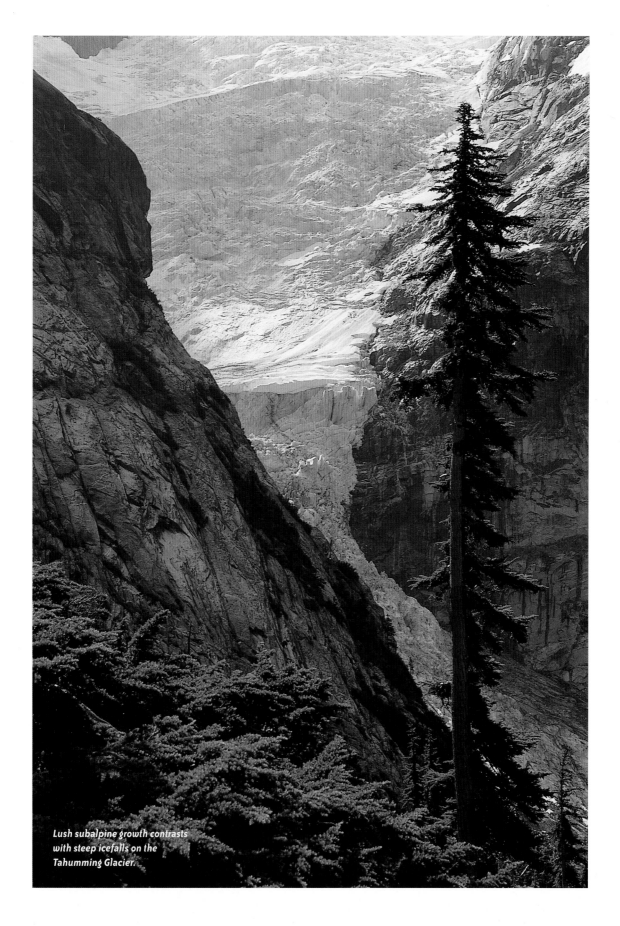

Lush subalpine growth contrasts with steep icefalls on the Tahumming Glacier.

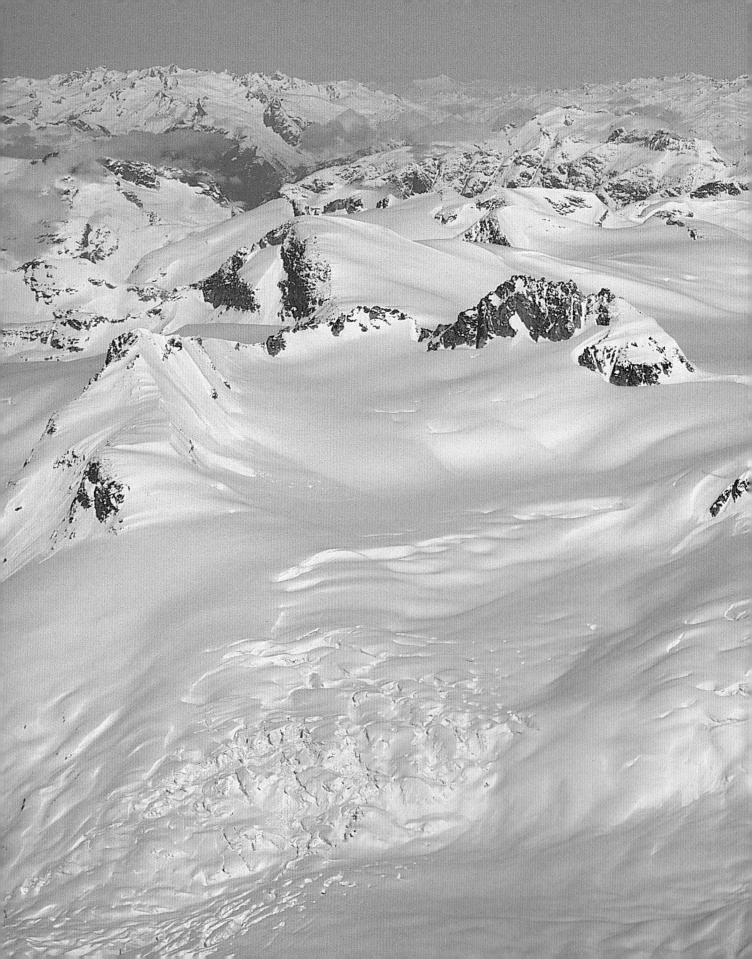

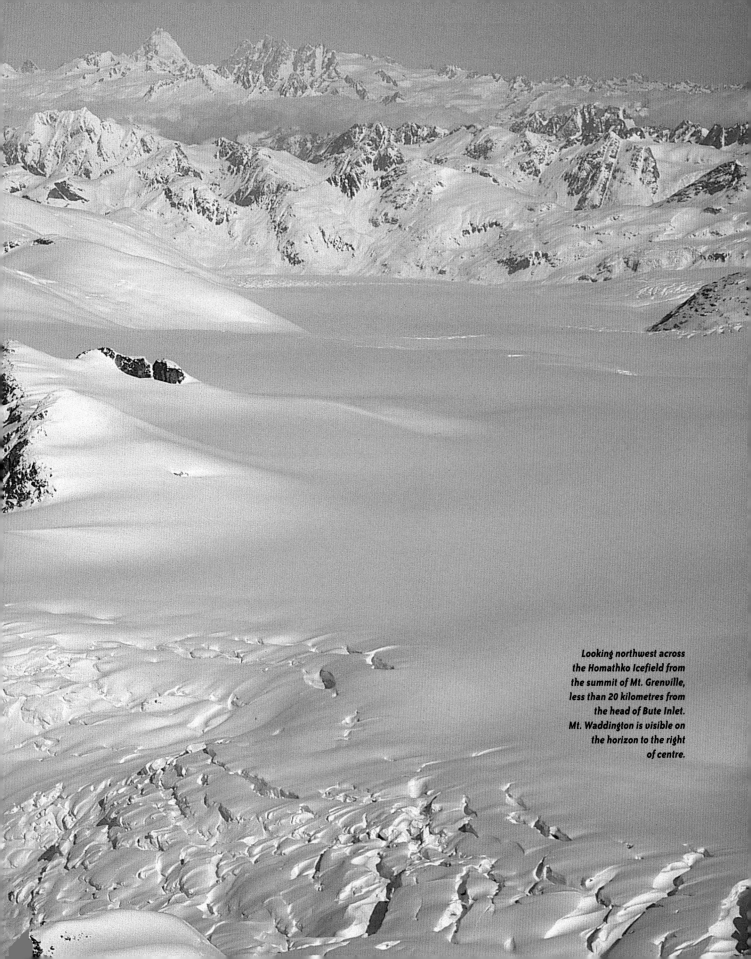

Looking northwest across the Homathko Icefield from the summit of Mt. Grenville, less than 20 kilometres from the head of Bute Inlet. Mt. Waddington is visible on the horizon to the right of centre.

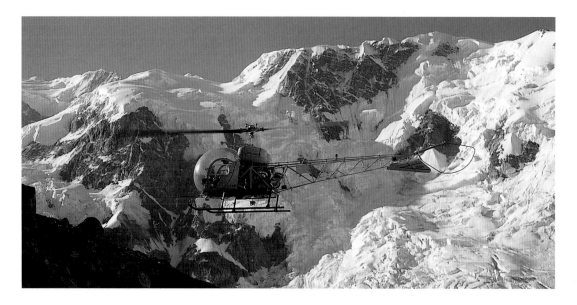

Above: Mike King of Whitesaddle Air ferries a load of climbers onto the Scimitar Glacier in the Waddington Range. The availability of helicopters played an important role in the exploration of the Coast Mountains.

Right: The lush green leaves of skunk cabbage thrive in the coastal rain forest and contrast sharply with alpine images.

Beginning in the 1950s two outside influences began to change the face of mountaineering in the Coast Mountains. The first of these was the availability of float planes and later helicopters. Earlier climbers had literally spent most of their time relaying food supplies and getting to the mountain they wished to climb. With air support it became possible to fly food (and later climbers) high onto the mountains and eliminate much of the difficult, time-consuming work of approaches. This hastened the continued exploration of various parts of the Coast Mountains into the 1960s. At the same time there was a worldwide shift in mountaineering away from the idea of grand exploration, toward more technical climbing. This was a natural progression in places such as the European Alps and the Canadian Rockies, where improvements in skill and equipment had drawn climbers onto steeper ground, away from the long-established routes to the mountain summits. In the Coast Mountains, however, it left huge areas of summits that remained unclimbed into the 1970s and '80s. Most were remote peaks that either were not high enough or lacked sufficient technical merit to draw modern climbers.

For this reason, exploration went on much longer in the Coast Mountains. Many of the mountaineering trips on which the photographs in this book were taken were exploratory in nature, involving first ascents of several hundred unclimbed summits, and traverses of more than half a dozen uncrossed icefields. These have been accomplished "On Foot" and "On Skis" and

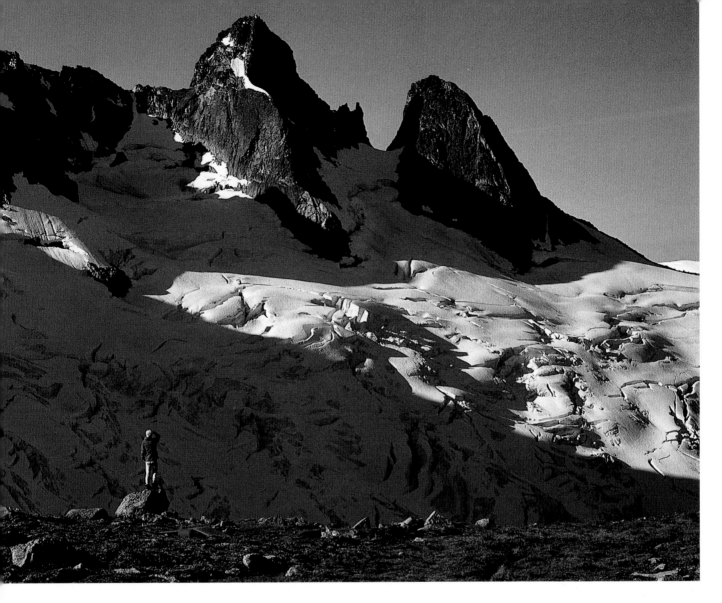

the book is organized to reflect this. I have attempted to mix a personal account of my mountaineering adventures with descriptions of the nature of the mountains and what it is like to visit and climb them. However, this is not just a story about climbing mountains. Somehow for me climbing mountains has always been more like being at the beach when you're a kid, lifting up barnacle-covered rocks to see what's under them. It's not that you expect to find anything but it's the looking—the exploring—that matters. It gives you a tremendous sense of purpose that puts a bit of spring into your legs and creates a spirit of discovery. As a result, each trip into the mountains is somehow akin to spending a long time with a person. Slowly the many facets of their personality are revealed and slowly a deep friendship develops between the climber and the mountains. This has a strong influence on one's connection with nature and is the subject of the fourth section, "Into the Silence." Photographs in this book have been selected to portray as many facets of the Coast Mountains as space permits without trying to provide a comprehensive picture of the range in a geographical sense. Most climbing trips focussed on the southern third of the Coast Mountains between Vancouver and the small town of Bella Coola, in what is known formally as the Pacific Ranges. The selection of photographs reflects this. Because of the nature of the trips photographic equipment was limited to a Pentax 35 mm camera and a small number of lenses. Kodachrome and Fuji Velvia film were used exclusively.

John Clarke admires an unnamed and unclimbed 2,224-metre summit west of South Bentinck Arm. Huge areas of summits such as this remained unclimbed well into the 1980s and were the driving force behind many of the mountaineering trips on which these photographs were taken.

21

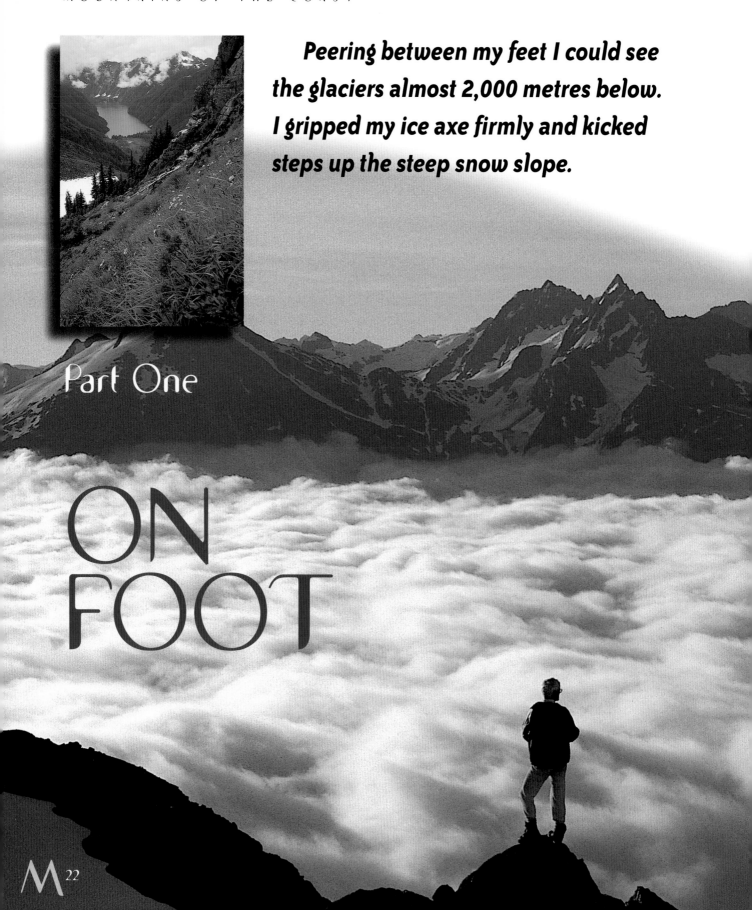

Peering between my feet I could see the glaciers almost 2,000 metres below. I gripped my ice axe firmly and kicked steps up the steep snow slope.

Part One

ON FOOT

This was the last rope length of my ascent of Mt. Waddington's narrow summit, but I kept my excitement focussed on my balance until I was able to complete the last few steps. From this towering summit, the highest in the Coast Mountains, I gazed spellbound at the spectacular landscape and considered the twisted path that had led me here seven years earlier, when I had first started climbing in the Coast Mountains.

My first journeys into the remoter parts of this range were from the interior or east side of the Coast Mountains. Here, alpine areas are relatively accessible from side roads extending into the edges of the range and offer the easiest routes into these rugged mountains. The inspiration for these excursions came from stories of previous trips in the *Canadian Alpine Journal* or from routes described in the 1965 edition of *A Climber's Guide to the Coastal Ranges of BC* by Dick Culbert. For climbers, this guidebook was like the Bible of the Coast Mountains, and a whole generation of climbers—including myself—read and reread every page to glean as much information as possible from the condensed descriptions of wild mountains. Despite being somewhat out of date (even in the 1970s) it is still the only climber's guidebook to most of the Coast Mountains!

For a young climber accustomed to weekend trips to mountains near Vancouver, these first summer forays into the wilds of the Coast Mountains on foot were tremendously exciting. Broad subalpine valleys extended back into the mountains from the high Chilcotin Plateau.

Below left: After a two-day rainstorm, John Clarke eagerly peers over early morning low cloud filling Bute Inlet.

Inset, below: Wayne Nagata pauses for a rest after reaching alpine meadows south of Junker Lake in Tweedsmuir Provincial Park. The Coast Mountains are most easily accessible from the interior side of the range, where broad subalpine valleys such as these extend back into the mountains.

Inset, opposite: A lone alpine flower, Indian paintbrush, high above an unnamed lake at the head of the Kwatna River.

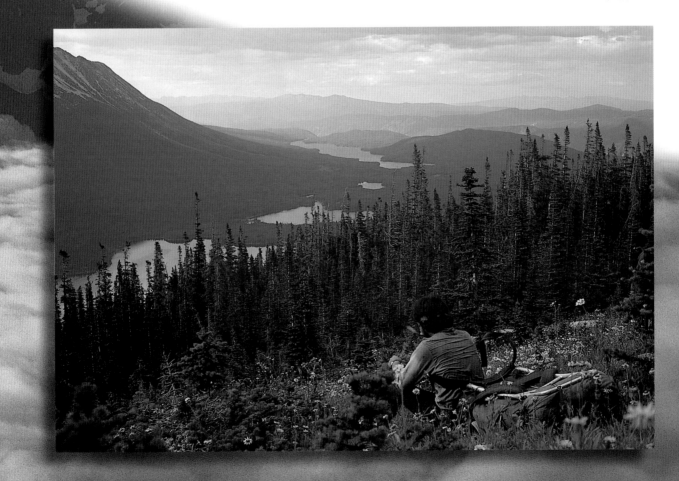

Despite the general lack of trails, many of these interior valleys were relatively easy to travel. The forest is reasonably open and game trails, sandbars and grassy clearings made walking not too difficult. From many valleys extensive alpine meadows, high mountain lakes and gentle glaciers could be reached in only a few days of travel from where a high camp provided a base for climbing nearby mountains and exploring the surrounding alpine country. It was the perfect introduction to the Coast Mountains, and we learned the hard way that bad weather, steep slopes, glacier travel, high cols and river crossings demand as much skill as mountaineering. I would return home tired, wet and usually bug-bitten, but with vivid memories of wild mountain landscapes and views of distant peaks and snowfields that would form the basis of future trips. We were not exploring in the true sense of the word—many of these mountains had been climbed in the 1960s or earlier—but there was a tremendous sense of discovery. It was like putting together a puzzle that linked the Vancouver area, where I had grown up, to the Coast Mountains, which I had stared at for many hours, wondering what lay beyond the dark green slopes and snow-capped summits that rise above the city, marking the changes in season as they faded to blue and grey before the first dustings of winter snow.

One of the greatest lures of the Coast Mountains is Mt. Waddington, and it was only natural the goal of several of my early trips was the Waddington area. Not only is Mt. Waddington the highest summit in the range, but the Waddington Range contains some of the Coast Mountains' most spectacular peaks and glaciers. While most other high summits in the Coast Mountains rise to elevations of 3,000 metres, the main summit of Mt. Waddington reaches 1,000 metres higher, towering head and shoulders above surrounding summits. Mountains are usually first climbed by their easiest route, but the first ascent of Mt. Waddington in 1936 was via its huge south face because it was the only face that could be easily reached—the difficulties of getting to Mt. Waddington were almost as complex as unravelling the easiest route up the main summit. After several seasons of exploring the area in the 1920s,

The Scimitar Glacier was used by early climbers trying to approach the Waddington Range from the interior side of the Coast Mountains. Mt. Tiedemann, just right of centre, rises over 2,600 metres above the glacier in the foreground.

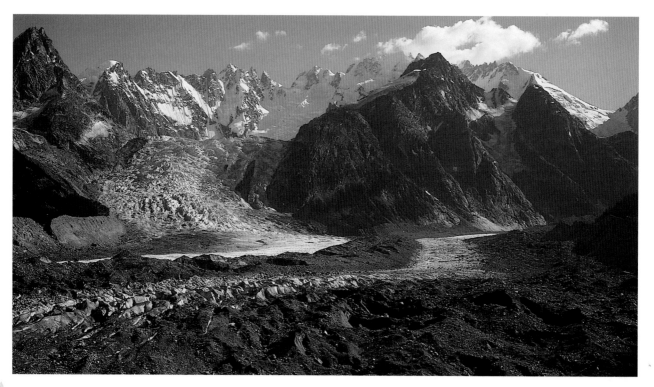

Don and Phyllis Munday settled on the southern Franklin Glacier as the best approach to the mountain. This required relaying heavy packs 16 kilometres up the dense coastal forest beside the Franklin River from Knight Inlet and then a further 20 kilometres up the Franklin Glacier, leading climbers to the south side of the mountain. Travel around the mountain is extremely difficult, however, because glaciers that radiate from the summit like the spokes of a wheel are separated by rugged peaks. Attempts were made to reach the north and east sides of the mountain from other approaches, but a route up the final rock tower could not be found. The 800-metre south face withstood more than half a dozen attempts and in 1936 was considered one of the most difficult alpine routes in North America. It has been included in a book titled *Fifty Classic Climbs of North America* and still boasts fewer than a dozen ascents.

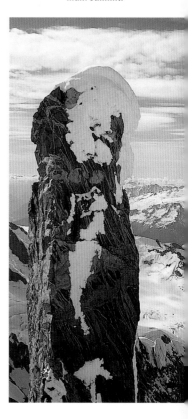

Left: Climbers eventually settled on the Franklin Glacier as the best route into the Waddington Range. The glacier leads directly to the 800-metre south face, visible in the distance.

Below: A sub-peak of Mt. Waddington, known as The Tooth, photographed from just below the main summit.

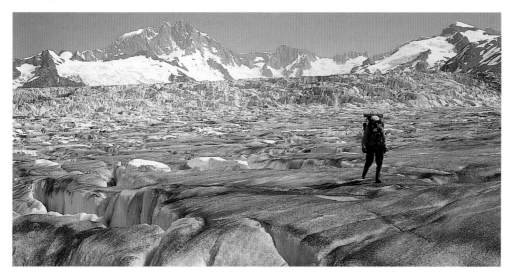

It was not until 1950 that the standard route now used to climb Mt. Waddington was discovered. Lying on the southeast side of the mountain where the final rock tower rises only 200 metres from the upper snowfields, this route follows a series of gullies to the summit. Though the length and difficulty of the route are considerably easier than the south face route, the final tower can be plastered in extremely treacherous ice feathers even in the middle of summer and is still climbed by fewer than a dozen parties a year. My ascent of Mt. Waddington, in 1981, was on my second trip into the area. After spending a week climbing peaks to the north we dropped down to the Tiedemann Glacier, where Mt. Waddington forms the head of a huge cirque of mountains and icefalls that rise 1,500 to 2,000 metres from the main glacier. The approach to the summit navigates the steep icefalls and bergschrunds on the Bravo Glacier and we made our high camp on a shoulder below the final rock tower amidst views of the Tiedemann Glacier stretching to the east. We awoke early for the climb. Conditions were unusually superb as our party of six worked our way carefully up lower angled rock into the notch between the main summit and a subpeak to the southeast known as The Tooth. From the notch the final chimneys, which in the 1930s had eluded many attempts on the summit from this side, led easily through the last band of steep rock to the narrow summit. Mt. Waddington has been called the Apex of the Coast Mountains, and no term could better describe the view of huge glaciers radiating in all directions like a great sunburst, and distant summits receding to the horizon. It was a gorgeous summer day and we could see for 150 kilometres in every direction. A few familiar summits could be picked out but as I looked around at the vast sea of mountains it was clear that my apprenticeship in the Coast Mountains had only begun.

Below: Rising directly opposite Mt. Waddington, the summits of (left to right) Combatant Mountain, Mt. Tiedemann, Asperity Mountain and Serra Peaks I to V offer some of the most difficult technical climbs in the Coast Mountains.

Bottom: Jean Heineman climbs onto the upper snowfield below the summit of Mt. Waddington. Behind, the mountains stretch southward toward the icy Whitemantle Range.

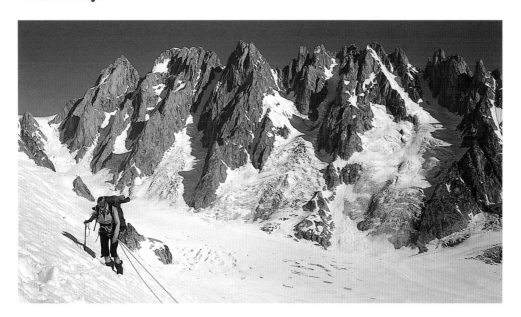

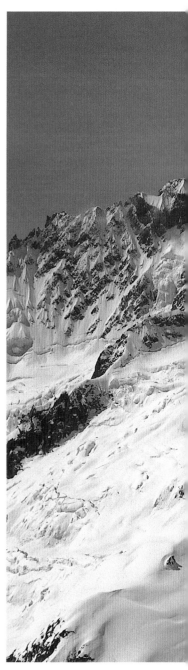

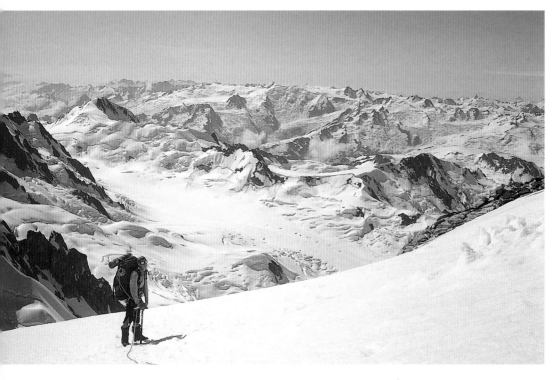

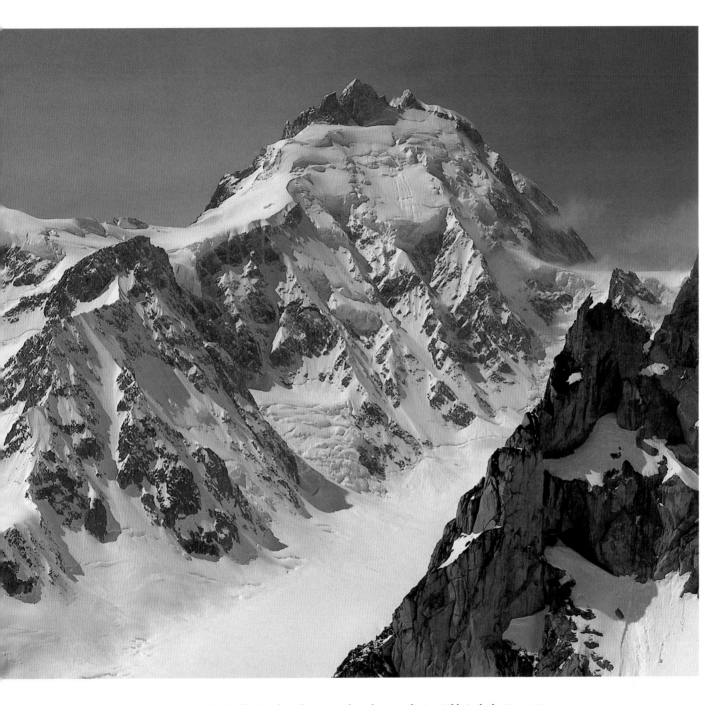

Mt. Waddington from the east, with Tiedemann Glacier visible in the bottom centre of the photograph. The standard climbing route ascends the crevassed Bravo Glacier from the bottom left corner of the photograph to gain the upper snowfield below the final rock tower. From there the summit is a moderate roped climb in good conditions. The crux of the route lies in an ice-choked chimney that climbs out of the notch to the left of the summit.

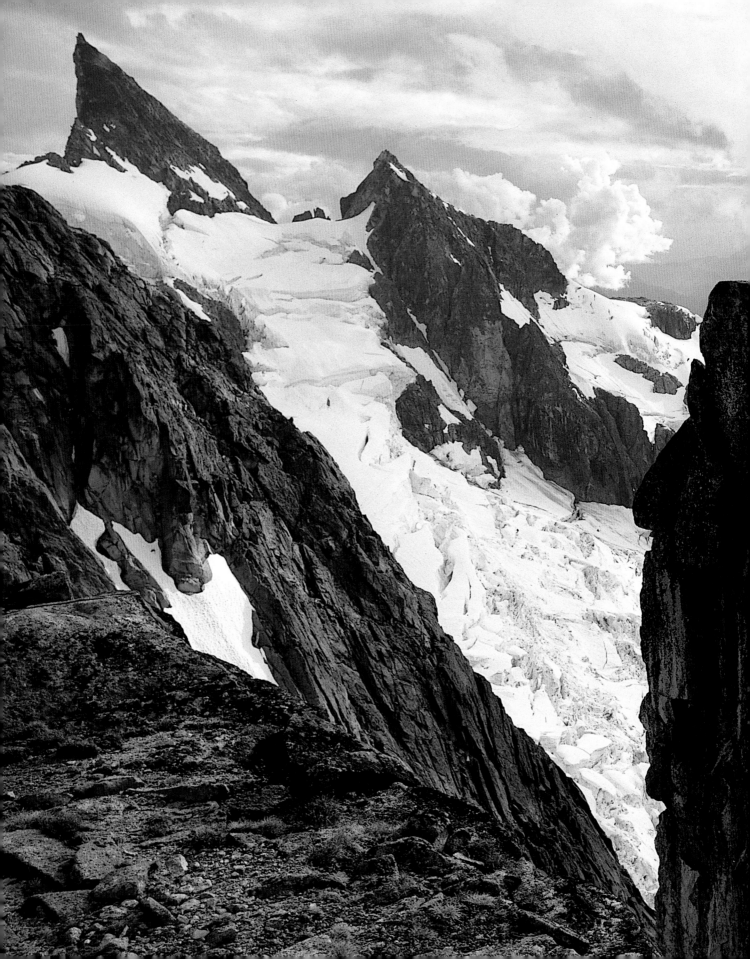

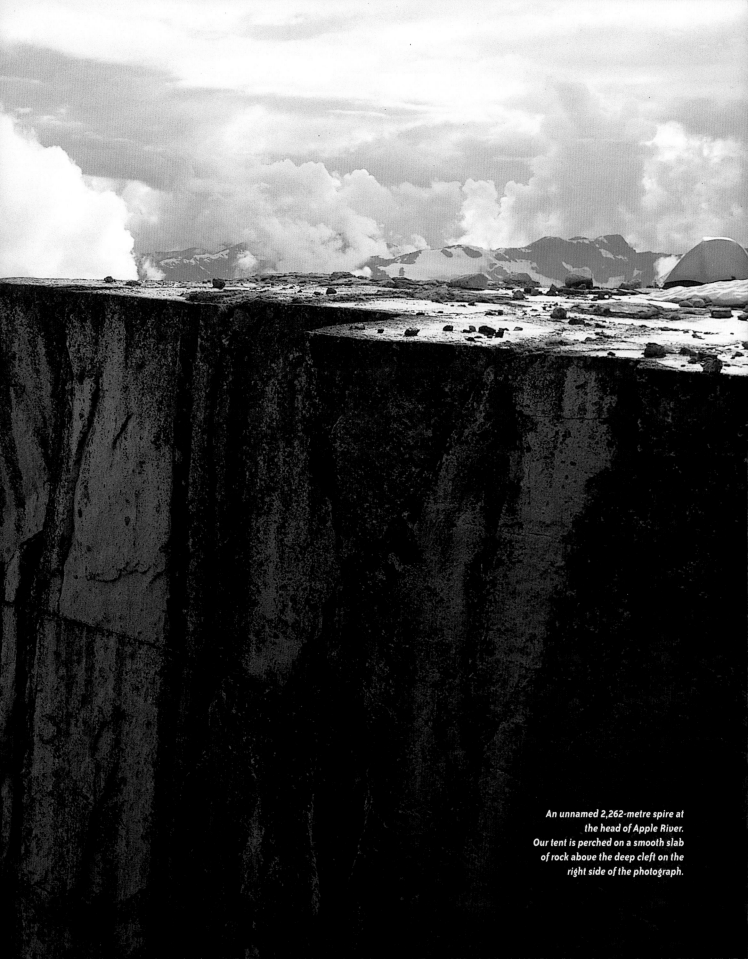

An unnamed 2,262-metre spire at the head of Apple River. Our tent is perched on a smooth slab of rock above the deep cleft on the right side of the photograph.

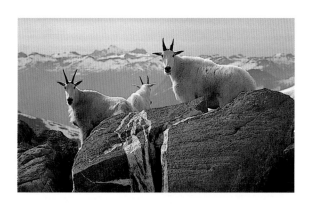

Right: I was lucky enough to photograph these goats above the Tahumming River before they were startled by my presence.

Below: John Clarke packs across a broad neve at the head of Wahkash Creek on a three-week traverse through unvisited ranges between Bute and Knight Inlets.

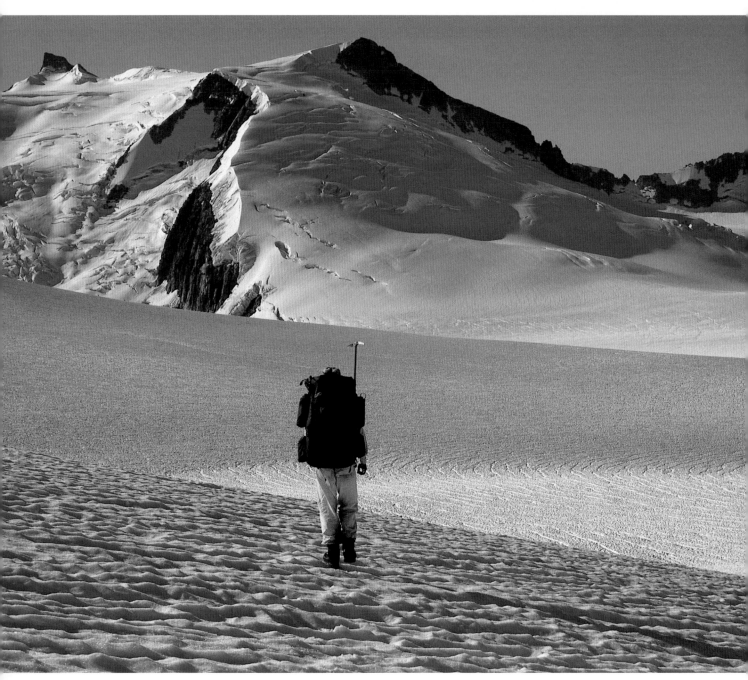

Below: Lichen and moss have taken years to establish patterns on the gravel outwash flats below the snout of the Pashleth Glacier.

Bottom: Late into the summer, as the ice begins to melt, drainage patterns on the snow contrast with chunks of ice on a high alpine lake.

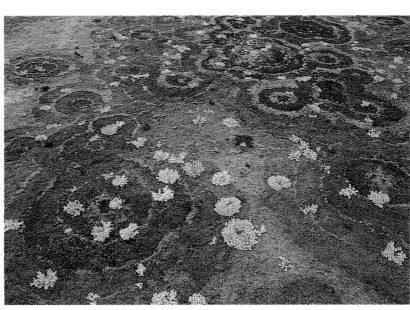

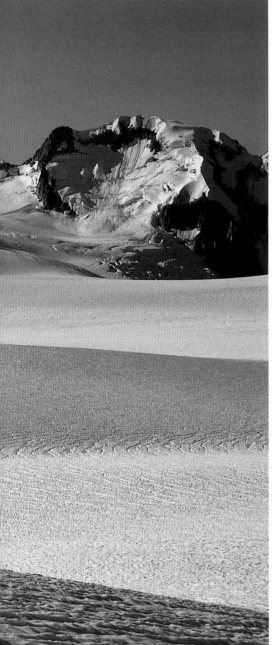

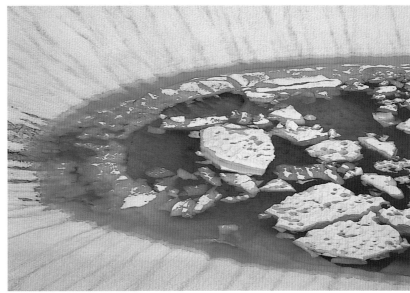

After the summit climb we finished our trip by following the classic route out over the Franklin Glacier. The ascent of Mt. Waddington had been the highlight of the trip, but this third week made just as much of a lasting impression on me. The time spent traversing the high snowfields, hopping over crevasses on the main trunk of the glacier and walking out to Knight Inlet served to place the summit in context with its location and history. But it also served to introduce me to the coastal side of the Coast Mountains, where the edges of the large icefields mingle with the long fingers of ocean that penetrate into the mountains. Here lies some of the most spectacular scenery in the range. Glaciers slop off the high peaks into deep coastal valleys and the mountains rise dramatically from the sea.

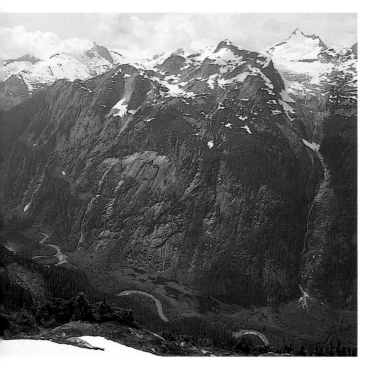

The Tahumming River is typical of the more rugged deep coastal valleys where the mountains rise essentially from sea level and some of the steepest terrain lies below treeline. Valleys are flanked by miles of cliff and slab, and getting to treeline is sometimes the most difficult part of a trip.

I returned home eager to learn more of these rugged summits. The old climber's guide revealed very little, barely mentioning huge areas of unclimbed mountains. It seemed incredible that large chunks of the Coast Mountains had not been visited by climbers. I pored over topographic maps, many of which had only been completed in the late 1970s, curious to know more of these areas. The mountains rose directly from the ocean and maps showed deep river valleys surrounded by mazes of peaks. Some of the steepest terrain lay below treeline, where the U-shaped coastal valleys had been carved out and oversteepened during the last ice age. As a result, valleys were flanked by miles of cliff and slab, and even the map sheets in some areas took on a brown shade from the heavy cramming of contours. Mountains formed the sides of the deep valleys so that adjacent river valleys were separated by long, narrow ranges that rose essentially from sea level on both sides.

A couple of exploratory trips to the coastal regions revealed more detail on the idiosyncrasies of travel on this side of the range. Bush in these coastal valleys is legendary. In some areas the only underbrush is a thick layer of moss or blueberry bushes. But in open areas, where the sunlight has a chance to penetrate the thick timber, twisted forests of slide alder and boulders make walking impossible and it is necessary to literally climb through the undergrowth. In valley bottoms or near winter slide paths the tangle of undergrowth can slow a strong party to less than 3 kilometres of travel in an entire day! Most renowned is devil's club, a plant that grows to head height. On steep side slopes the large leaves make it difficult to see where to place your feet, and should you slip on its roots or stocks the only thing to grab hold of for balance is the plant, which is entirely covered in thorns!

It quickly became clear that the only way to travel through these mountains was to climb onto one of the narrow divides and traverse its full length, following its sinuous path around the drainage of one of the major rivers. This, however, meant climbing not one or two summits on a trip but a whole range of peaks, travelling the entire distance in the alpine, crossing one mountain after another.

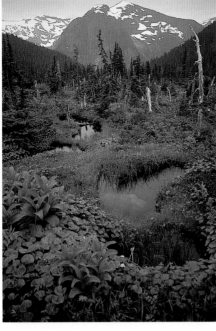

Left: Moist subalpine meadows near Shames Mountain support very lush growth.

Left: Travel in the thick bush of the coastal rain forest can be exceedingly slow, sometimes reducing a strong party to less than 3 kilometres in an entire day. Here, John Clarke peers up from a thicket of the legendary devil's club.

Below: Mountains on the coast tend to form long, narrow divides such as these above Stanton Creek. The only practical way to travel is to follow the crest of the divides, walking the entire distance in the alpine.

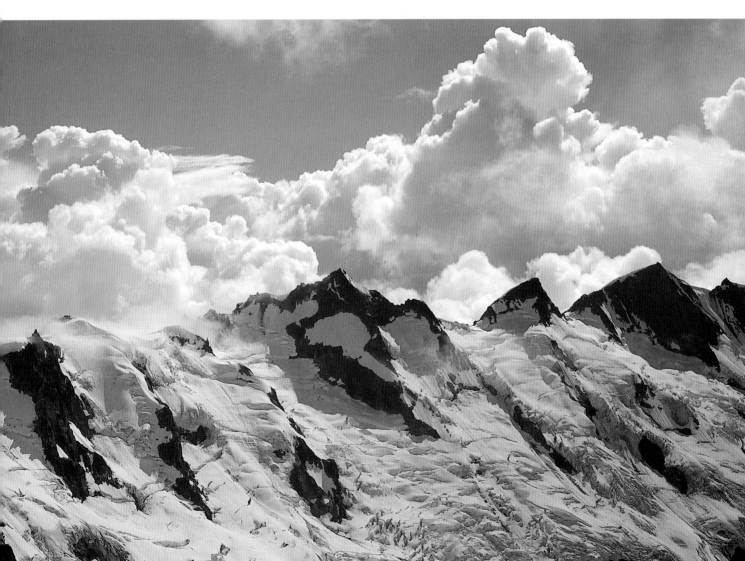

Right: Eda Kadar washes dishes in a small creek on the high alpine plateau surrounding Mt. Edziza. Reminiscent of the Arctic, this photograph shows a rare view of the interior side of the northern Boundary Ranges, with the more icy peaks near the centre of the range beyond.

Below: Early morning sunlight filters down onto the tranquil waters at the head of Toba Inlet.

Opposite: A steep cliff towers above a subalpine meadow in the rugged mountains at the head of the Tahumming River.

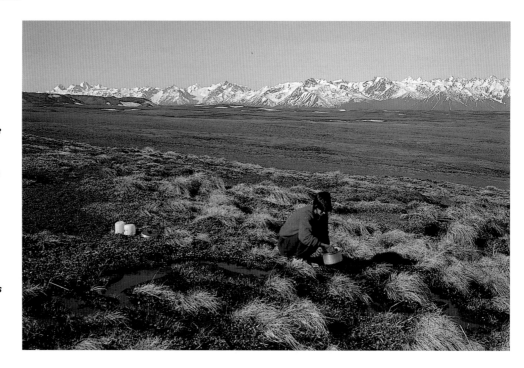

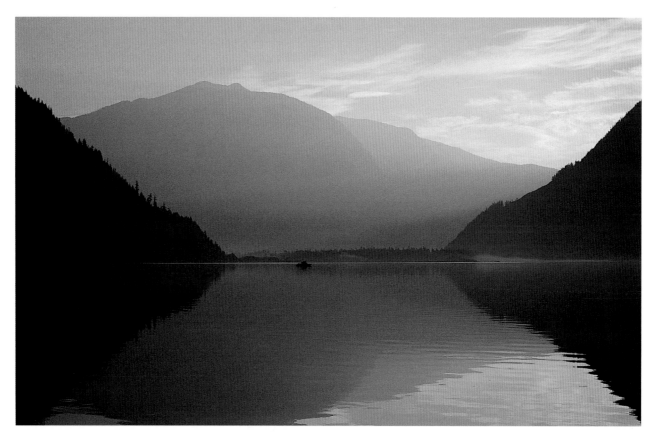

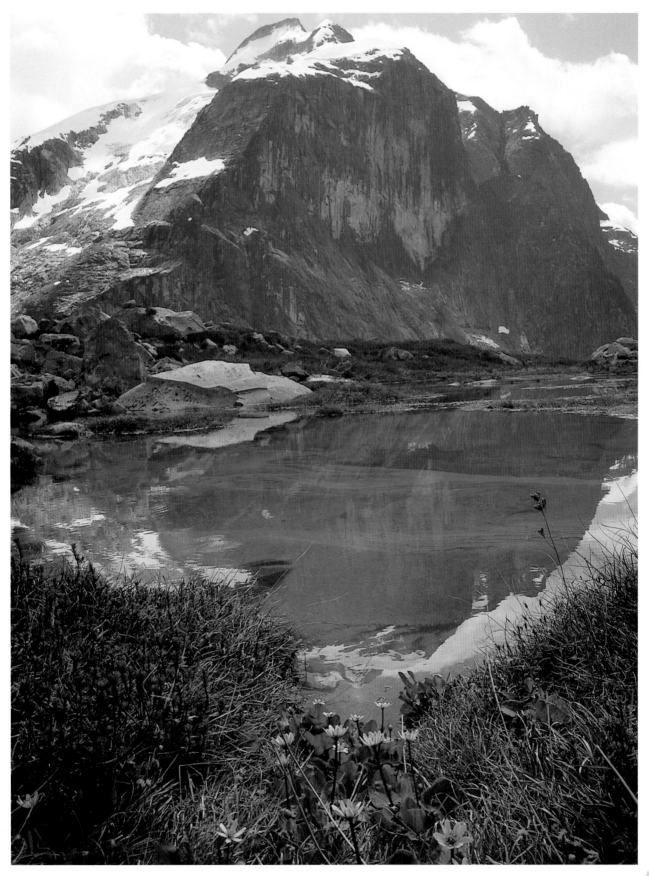

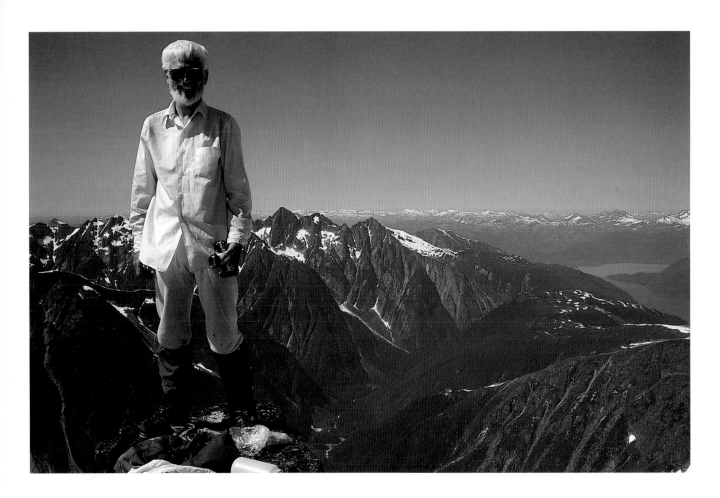

John Clarke, my partner
on summer trips for more
than twelve years,
is shown here on the summit
of Peak 7412— an unnamed
mountain west of South
Bentinck Arm.

Around this time I met a fellow climber, John Clarke, who had already spent more than ten years exploring the Coast Mountains. With our common passion for the remote corners of these ranges we spent nearly every summer for the next twelve years venturing to one area of the Coast Mountains after another. Together John and I spent hours poring over topographic maps, looking for routes that would lead us to the wonders of these coastal peaks. Access to the alpine from the deep coastal valleys was severely limited by waterfalls, cliffs and icefalls while on most of the narrow coastal ridges there was only one route through the maze of mountains and that was along the crest of the alpine divides. Thus each trip had to be planned carefully. We studied topographic maps meticulously to check the route for any difficult sections that might block the way, and when the map was not clear we consulted aerial photographs. Allowances had to be made for bad weather and for side trips. We also studied any possible escape routes and the location of any logging roads.

Most of our trips were two to three weeks in length, and most followed a familiar pattern, traversing the narrow skyline of high coastal divides, often from one inlet to another. Many of our first trips to this side of the range were to the mountains around Bute and Toba inlets. Access is by float plane from Campbell River on Vancouver Island. There is always an abrupt transition on the flight up one of these inlets. The wide, sandy beaches of Vancouver Island are left behind as the plane flies inland, passing over a maze of islands and channels. Mountains begin to rise up around the float plane and the clear blue water of Georgia Strait gradually gives way to the silt-laden colour of the inlets. We are usually deposited on the rocky shore of the inlet or sometimes at an old wharf at an abandoned logging camp. An incredible silence hangs in the air as the plane flies away.

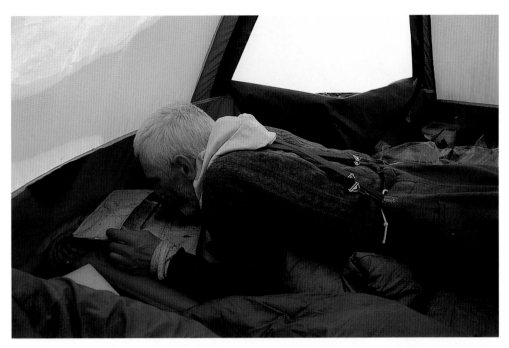

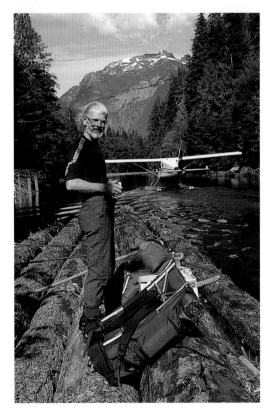

Left: We spend countless hours poring over detailed topographic maps of our intended route.

Below left: Rugged alpine terrain such as this wild view of a glacier snout tumbling over a cliff makes careful route planning essential.

Below right: A float plane drops John Clarke and me off on a log boom in Cumsack Creek at the head of Bute Inlet for a two-week traverse across the Whitemantle Range.

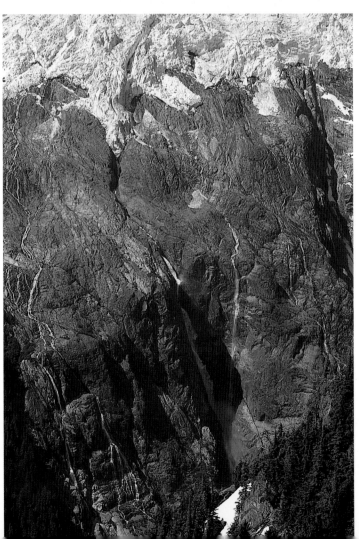

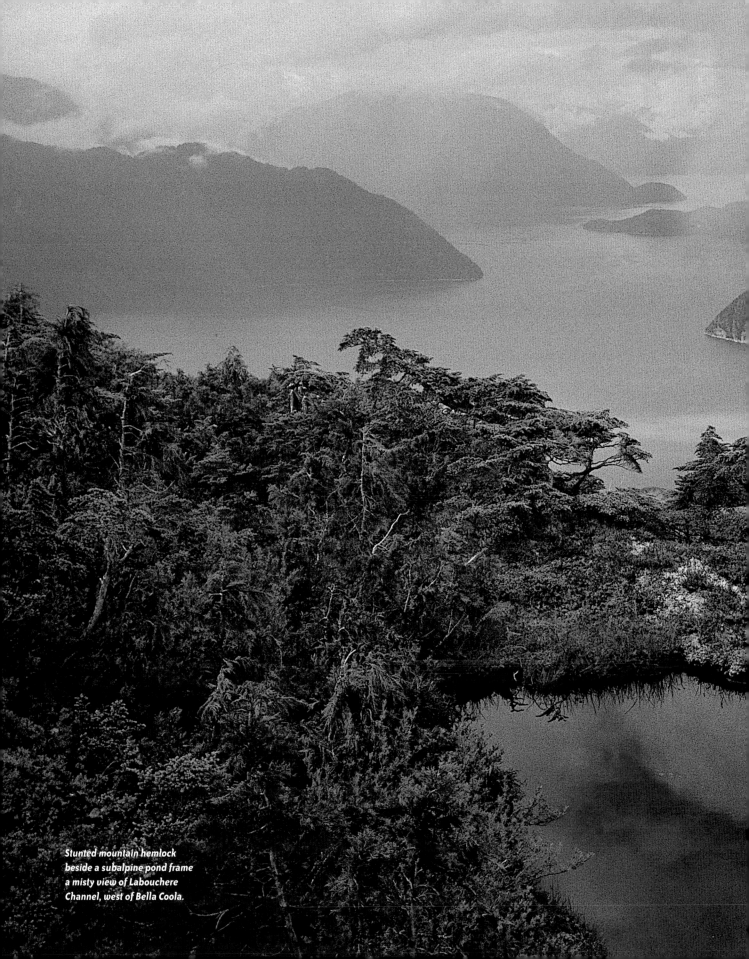

Stunted mountain hemlock beside a subalpine pond frame a misty view of Labouchere Channel, west of Bella Coola.

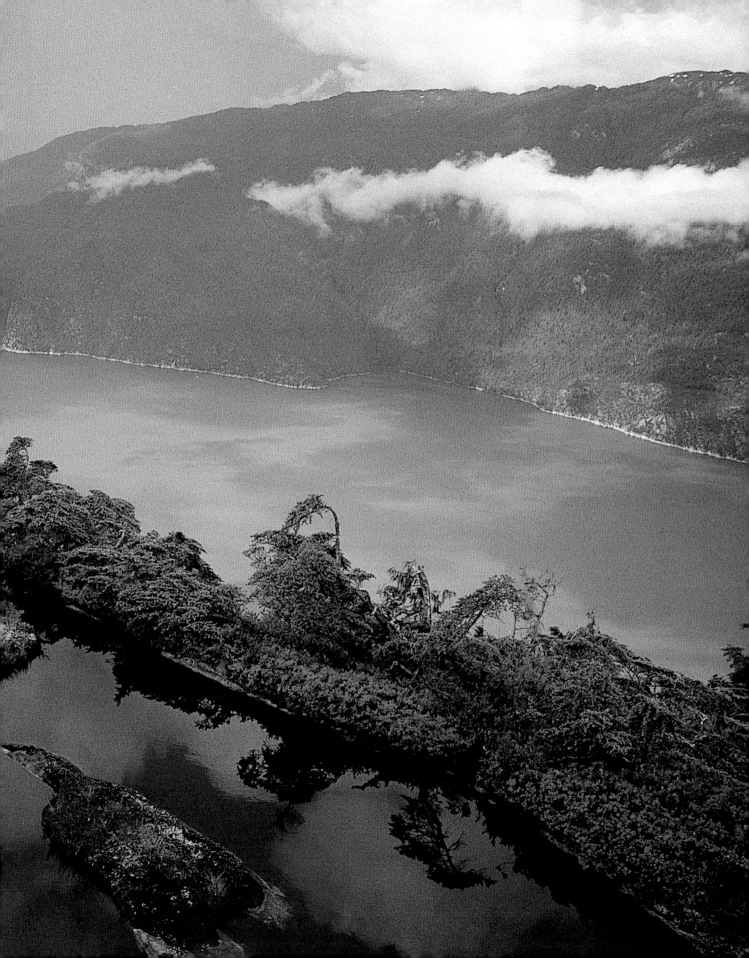

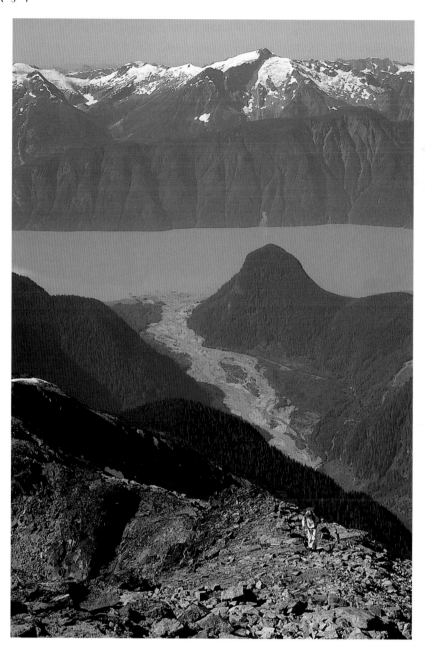

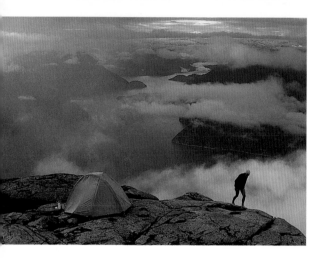

Top: Thick moss adorns the branches of a broadleaf maple.

Right: The final climb into the alpine from the shores of the inlets is always stunning. John Clarke climbs above Knight Inlet and the mouth of the Franklin River.

Above: John Clarke wanders across a rock slab by our tent above Burke Channel.

Summer mornings begin slowly in these deep fjords. On a trip to the head of Toba Inlet I wrote: "A cold early morning mist follows the icy waters of the Toba River out into the inlet, as the sun begins to filter down from the mountaintops into this deep hollow. Curious seals raise their foreheads out of the water. An eagle looks down from atop a large cedar tree and high in the sky the cry of a raven echoes from the cliffs to blend with the sound of waterfalls. Out of this stillness rise the mountains and it is here that we shoulder our packs and slither through the wall of bush at the water's edge to enter the forest. Large hemlock and spruce trees tower above us, their branches draped in a thick coat of moss. Under this canopy a magnificent proliferation of undergrowth vies for the remaining light and soaks up the endless supply of moisture. This rain forest is easily comparable to any tropical jungle and in its own way is as spectacular as the mountains that surround it."

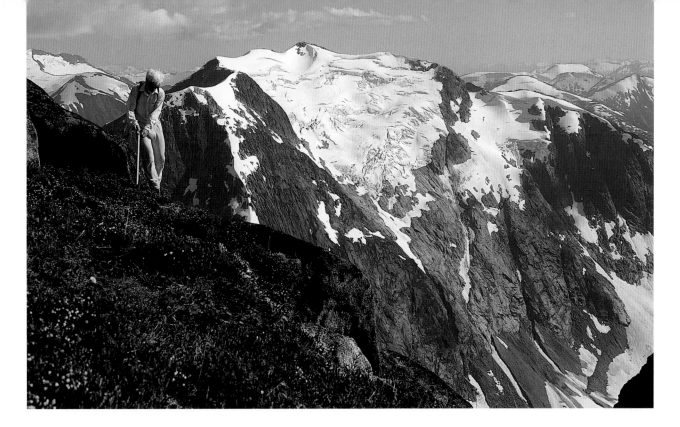

We make the strenuous climb up to the alpine from sea level by struggling up the steep sides of the U-shaped valleys. This is always a long, sweaty day during which we are burdened with heavy, cumbersome packs, and there is often no place to camp and no water en route. But when we reach the alpine it is like entering an altogether different world. Views of the surrounding landscape are spectacular. Sweeping up from the sea are the smooth curves of dark green wooded slopes, broken here and there by waterfalls and soaring slabs of rock. And all around huge uplifts of snow-covered mountains tower above the deep valleys.

It is the peak of summer, and for the next two to three weeks we travel along narrow ridge crests on bare rock, heather and seasonal snow. We cross glaciers and icefalls, and walk along narrow goat trails that lead past clumps of ancient stunted trees. Our camps are perched high on the peaks amidst flowering heather and slabs of rock, and the evening sun paints warm shades of pink on the surrounding snowfields and icefalls. There is a tremendous feeling that comes over us on a trip like this, with so much to see and do, and all of it unknown. Sometimes valley fog oozes over ridge crests and everywhere far below us are the deep winding valleys of unexplored rivers such as the Toba, Tahumming, Bear, Kingcome, Atlatzi, Inziana and Chuckwalla. Though we are continuously in the alpine, it is the incredible contrast between the relatively easy travelling on the ridge crests and the ruggedness of these wild valleys that makes the mountains feel so remote. An example of this is the narrow icy divide we visited in 1990 that separates the upper reaches of the Clyak River from the Kilbella River. The entire south side of the divide is flanked by sheer 700-metre slabs and cliffs, while on the north side steep icefalls plunge out of sight into the deep trench of the Clyak River. For the most part the travelling is straightforward—usually we are walking on snow—but steep slopes and rock steps are a constant reminder that this is mountaineering and not backpacking. Our ice axes never leave our hands. Though the axe's main use is as a walking stick, its other function is to arrest a fall in the event we slip on the steep snow. We also carry crampons that strap on our boots for extra grip when the snow is frozen or the route crosses the lower portion of a glacier on bare ice. Occasionally we have to use our rope for short stretches of climbing.

John Clarke uses his ice axe as a walking stick on the crest of this high alpine divide above Clyak River. For the most part, travelling in the alpine on these coastal divides is relatively straightforward, but as a friend once said, "Sure it's hiking, but if you get off route you'll be using the rope to lower yourself off a cliff!"

On long trips in remote areas it is extremely important to be cautious at all times. This is a lesson I learned early in my climbing career—the hard way, unfortunately—during a hike up Hudson Bay Mountain above Smithers in 1977. A group of us had climbed up through the meadows from the ski area to gain the last ridge leading along to the summit. It was early in the summer, with the usual unsettled weather, and we walked on snow between the ridge crest and a huge cornice that hung out over the large cliffs on the east side of the mountain. At a flat point on the ridge it was my turn to lead and break trail for a while, but as I moved ahead the snow fractured and the entire area under my feet dropped like a trap door and sent me hurtling down the cliffs inside an avalanche of snow. The snow pounded and pummelled me in darkness until miraculously, at the bottom of the cliff, I was spewed out onto the glacier amidst piles of debris. I had injured my knee and sustained considerable internal bruising but otherwise I was unscathed. Incredulously I peered back up to the ridge crest 250 metres above, thankful to be alive.

Sometimes the route is obvious and at other times it remains mysteriously hidden, only to be discovered at the last minute. Every so often a maze of crevasses or a narrow ridge must be negotiated, but mostly there is a tremendous amount of up and down as we make our way through the alpine, climbing the steep sides of mountain after mountain. Often horizontal distances lose their significance and vertical relief becomes the governing measure of how far away a mountain is.

There is always a slow period after lunch, especially on a hot day, while we digest our food and absorb enough water to renew our bodies after vigorous sweating. But it is a wonderful feeling when after a few minutes of climbing all that tiredness drops away and you fly up the hill with your lungs breathing free and easy. Gaining substantial elevation with a heavy pack is a strenuous but harmless pastime that is completely free of any of the hassles and traps that so often interrupt the normal flow of things. Indeed, there is a kind of sweaty ease that is broken only by the regular, sometimes frantic, expansion and contraction of one's lungs and the rhythmic swish of first the right and then the left boot as they find purchase in the soft summer corn snow.

We make side trips to the tops of the mountains along our route. Many of these are unclimbed and we build a cairn to celebrate the first ascent. Most are non-technical rounded horns that require scrambling on steep rock or snow rather than any difficult roped climbing. At a time when modern climbers are completing difficult alpine-style ascents of the world's highest mountains, there is no question that these summits fall outside the mainstream of modern mountaineering. Most climbers despair at the amount of walking and lack of technical climbing involved in reaching the summits of these coastal peaks. The general sentiment is that they aren't important or worth climbing, and this is the main reason they are left behind. In a sense these climbers are right—there is no glory in conquering hundreds of "little" mountains—but it is a lot of fun. These little peaks were the driving force behind the weeks, months and years we spent tramping through thousands of square kilometres of mountains, allowing us to discover the incredible beauty of a seldom visited part of the earth.

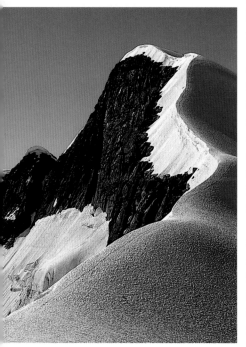

Winter snowstorms build unstable cornices of snow that hang out over cliffs such as this. It is extremely important to stay well away from the edge.

Opposite: In rugged terrain such as this above Stanton Creek, horizontal distances quickly lose their significance and vertical relief becomes the governing measure of how far away a mountain is. Surefootedness is especially important.

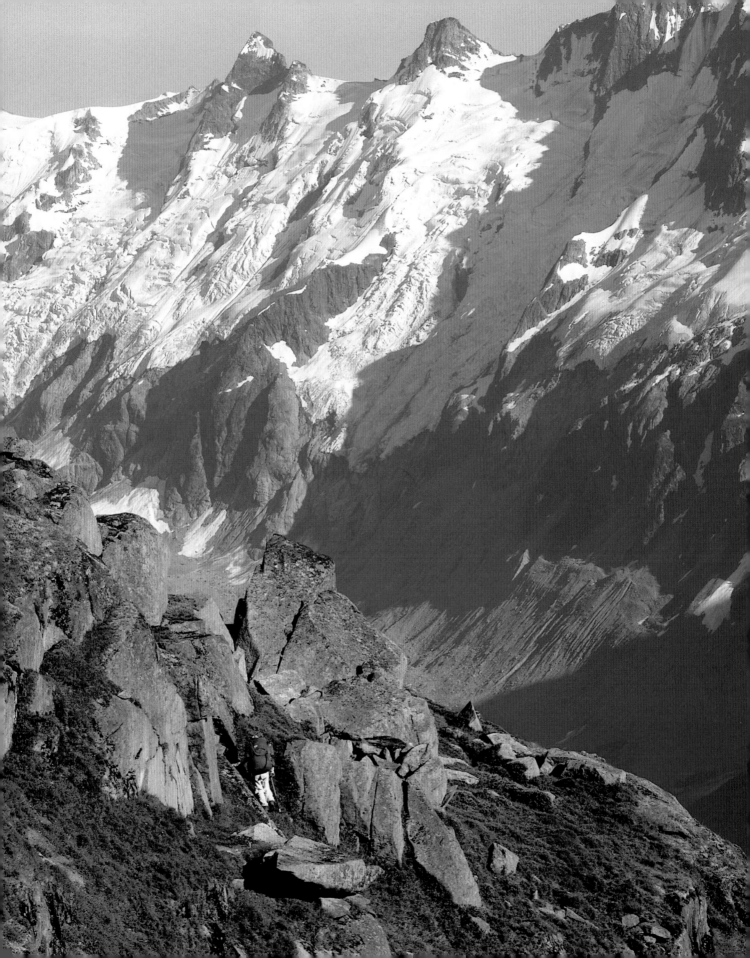

Because many areas of the Coast Mountains are relatively unexplored, hundreds of summits in large parts of the range have not been named. This is particularly true on the coastal side of the range, where only the major rivers and a few of the prominent summits visible from the ocean have names. John and I adopted the common practice of using the surveyed elevations given on maps in lieu of a name; hence the more spectacular of these peaks became numbers such as 8715 or 9535. To us these numbers had as much meaning as a name like Waddington or Everest and we could often be heard saying things like "I remember the view we had from eighty-six fifty-nine," or "How are we going to get around eighty-seven fifteen?"

A unique feature of the Coast Mountains is the strong contrast between north- and south-facing slopes. Peaks of modest height are often laden with large glaciers on their north sides while south-facing slopes are dotted with rocky meadows. These small, isolated patches of green are pasted on the steep slopes amidst slabs of rock and cliffs and provide a striking contrast with the rest of the icy landscape. Tiny flowers and small streams of clear water neatly trimmed with blades of grass give the illusion of a manicured garden, but in reality these meadows are a miniature jungle scaled down by the harsh conditions of their environment—they are buried in snow for almost ten months of the year. Yet by the end of July, when the warmer summer weather has melted all but the deepest drifts of snow, it is not uncommon to camp amidst flowering heather above the tumbling ice of a massive glacier. It is in places such as this that one sometimes stumbles upon small alpine tarns. Some are only the size of a bathtub while others are as big as a small swimming pool. A special delight on a warm summer day is to dive into their icy waters, exit very quickly and sprawl on the surrounding slabs of sun-baked rock to rewarm slowly.

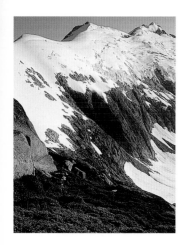

Above: South-facing meadows contrast sharply with glaciated north-facing slopes above the Clyak River.

Below: This contrast is also visible in this view of rocky meadows above Stanton Creek.

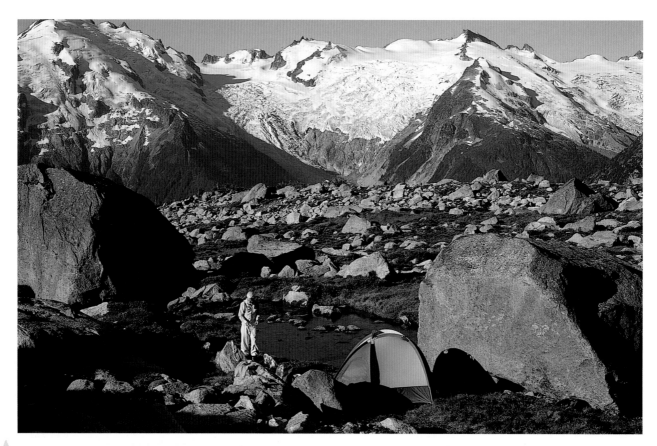

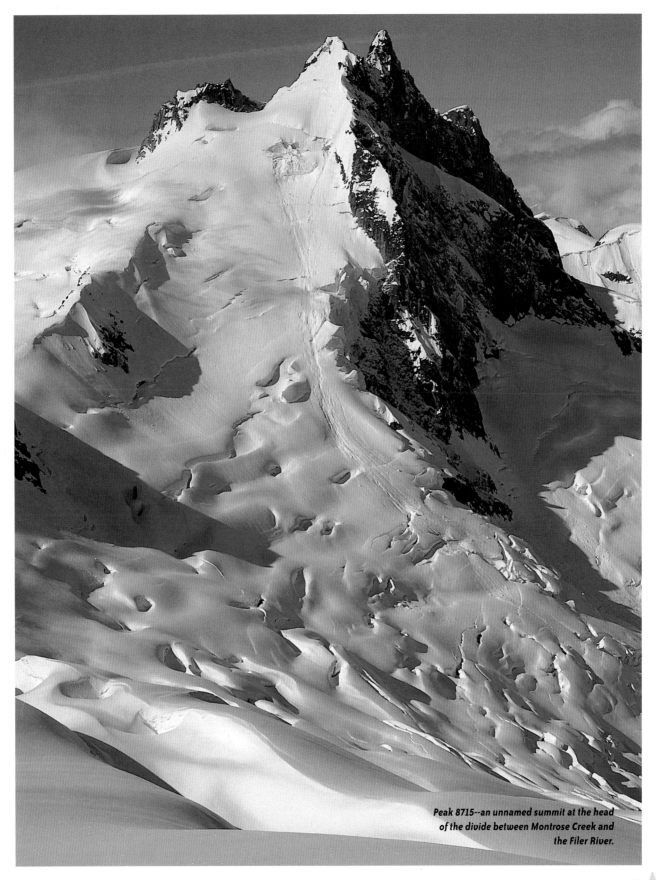

Peak 8715--an unnamed summit at the head of the divide between Montrose Creek and the Filer River.

Extended periods of sunshine occur only in the summer. It is on these rare days that many of the photographs in this book are taken, but it is not just the sunny days that leave a lasting impression. The days spent roaming in the mist and fog high on the side of these mountains reveal a different side of their character. The air is thick with moisture and the distinction between cloud and mountain is lost as you grope along. Occasionally it is necessary to stop dead in your tracks and wait, sometimes for hours or days, until the mists clear and your route is no longer a question mark. Distant sounds of running water and crumbling ice come and go as the wind dances about. Gaps in the clouds open and close and views are so brief and sporadic that it is hard to know if they are really as incredible as they seemed. On days such as this, one gets the feeling that these mountains are alive.

As the weeks go by time begins to take on a different quality. When you are immersed in the rhythm of these high mountains, it becomes a joy to feel your heartbeat as you climb onto an icefield, to hear the rumbling of a glacier and to lie on a patch of meadow, hot, panting and exhausted. There is the play of light and cloud on the steep, icy slopes, the rush of mountain streams and the feeling of space and movement in the air. These become old friends and a feeling of warmth fills your soul.

On most trips the hours of planning and poring over topographic maps paid off as our

Cloudy days are common even in the middle of summer, and views of distant peaks through gaps in the clouds reveal a different aspect of the mountains than scenic panoramas taken on bright sunny days.

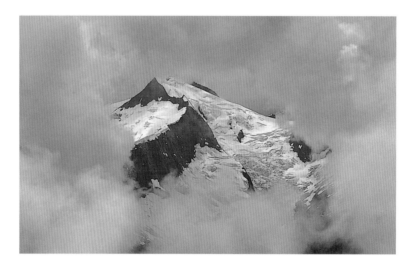

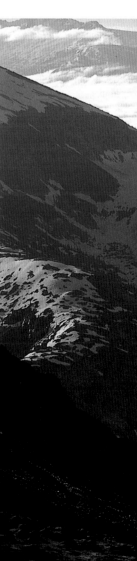

A telephoto view of the large cliffs on the Kakweiken Divide. The thin white diagonal line right of centre shows the ledge we miraculously discovered that led us from the mountain in the background onto the continuation of our intended route lower down.

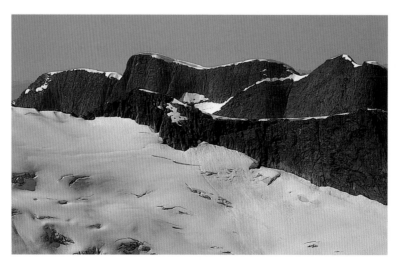

planned routes led smoothly between the lofty peaks. Yet on a few occasions we were halted when "viable" routes turned out to be totally impassable. This happened on a trip around the Klite River drainage when halfway into our trip a long slope that was to lead us around a sharp notch on the main divide turned out to be a huge slab of steep rock. Thwarted, we had only one choice: to abandon our planned traverse and backtrack along our route. Another incident—one of the most amazing for us—happened on a trip around the headwaters of the Kakweiken River. Each summit on the divide we were travelling had a steep, slabby cliff on its north side. These north faces grew successively higher and wider along our route until one whole side of the divide became a continuous cliff that stretched for more than 5 kilometres. As we struggled up mossy ledges in the fog we came to an utter dead end when we realized that the continuation of our traverse branched from the midpoint of this cliff. In the morning we scouted around in better weather until we came to the spot where we vaguely recalled seeing a weakness in the huge cliff while we were putting in airdrops. Miraculously, sneaking off to the right was a ledge about 2 metres wide, complete with trickles of water, flowering heather and moss. Following this incredible ledge we were able to walk diagonally down and across the cliff to where the main divide continued.

Marine cloud pours over this ridge south of the Kakweiken River, emphasizing the importance of good weather for high alpine travel.

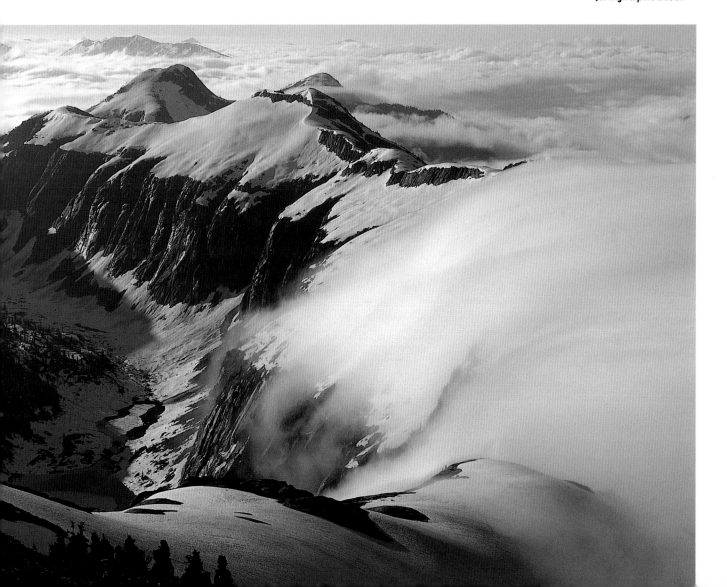

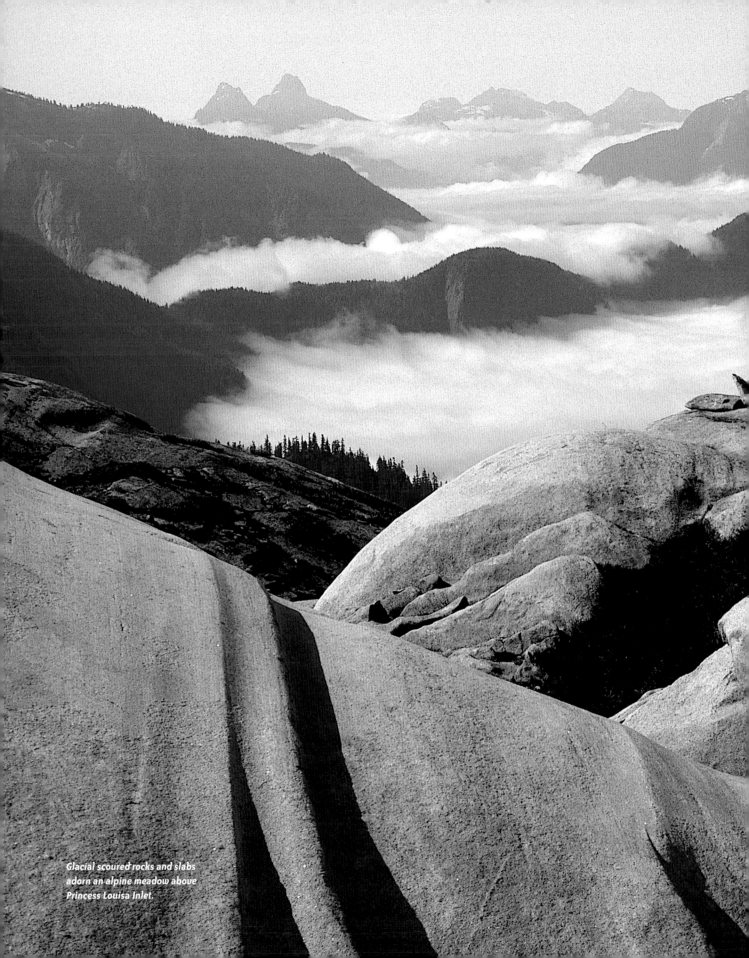

Glacial scoured rocks and slabs adorn an alpine meadow above Princess Louisa Inlet.

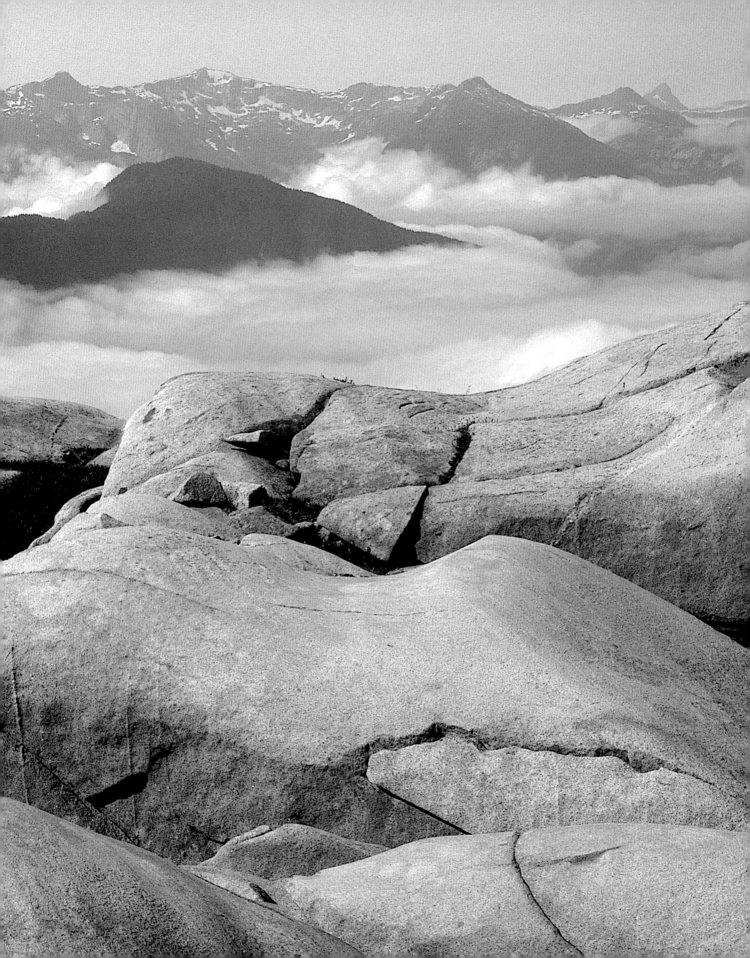

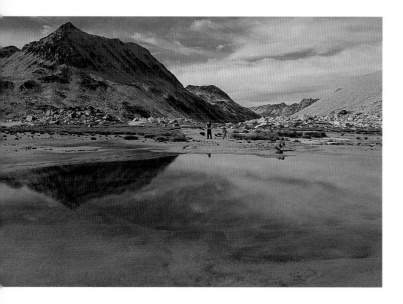

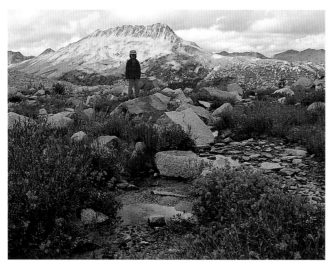

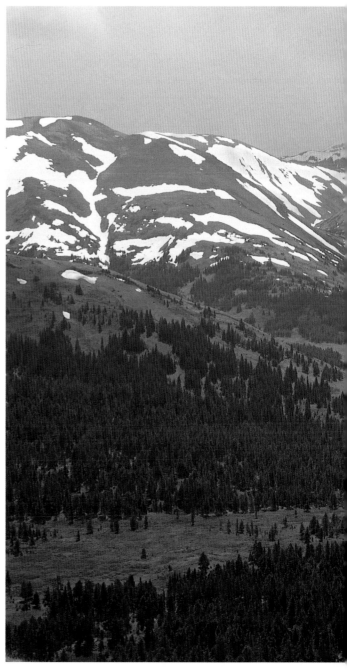

Top: My son Stephen plays with his cousins near a small alpine pool in the Dickson Range.

Above: My daughter Rachel enjoys her first view of alpine flowers in the Chilcotin Ranges.

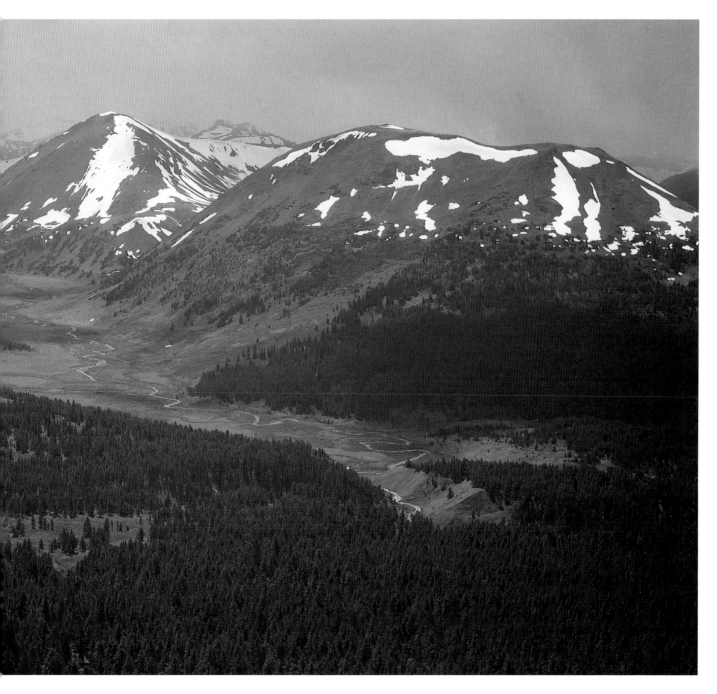

Above: Graveyard Creek in the Chilcotin Ranges is typical of the less rugged, friendlier look of the mountains on the interior side of the range.

Right: A mixture of alpine flowers, common in the lush meadows on the interior side of the Coast Mountains.

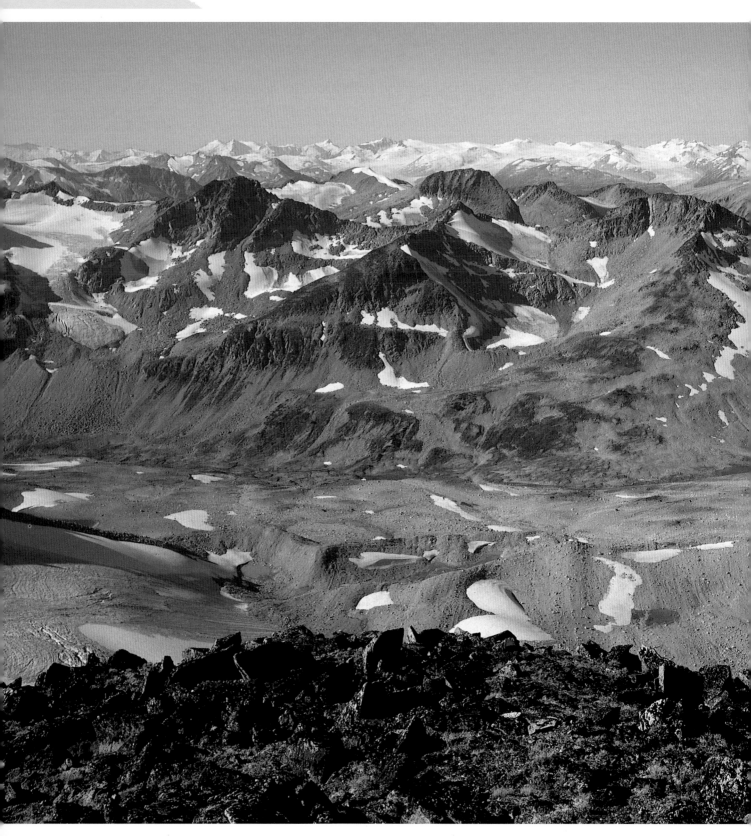

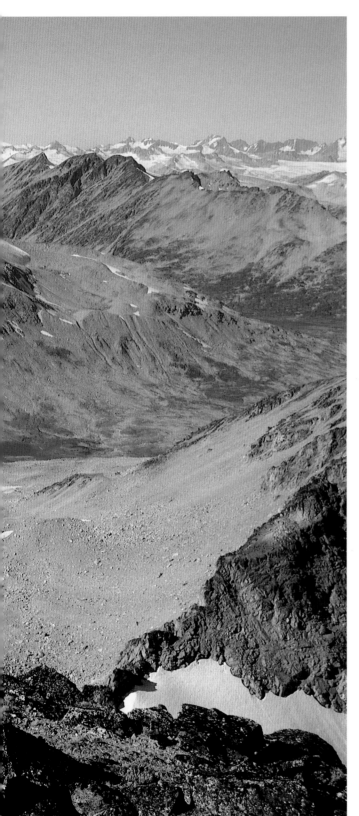

Left: Glaciation is less extensive on the interior side of the range, where broad subalpine valleys open up into wide areas of alpine meadows in the western end of the Dickson Range. The Lillooet Icefield is visible in the distance.

Below: A tiny clump of moss campion blossoms lie amidst shattered rock on a high alpine ridge.

Above: Running water forms a lacy pattern as it cascades down a rock face.

Steve Ludwig digs into a full bowl of steaming hot dinner after a long day in the mountains.

In mountaineering, food is second only to mountains! The rigours of carrying a heavy pack demand a diet of well over 4,000 calories a day. To keep weight to a minimum we carry only dried foods. Our days begin with a large bowl of oatmeal laced with butter and whole milk powder. Lunch is cheese on heavy whole wheat bread. Snacks are prunes, dried peaches and bananas, almonds and cashews, and a small amount of chocolate and other candy for those with a sweet tooth. The dinner menu offers a different meal for each day of the week. Choices include curried shrimp and rice, spaghetti and dried hamburger, macaroni and tuna, mashed potatoes and landjaeger sausage, or lentils and rice. Dinner always begins with soup. We buy our ingredients from bulk food stores in Vancouver (such as Famous Foods) and package them in separate bags for each meal. All dinners are boiled in a single pot on a small gas stove and, not surprisingly, resemble mushy casseroles. But never will you see happier faces than the ones on a couple of hungry climbers holding large bowls of steaming food after a long day. Beverages made from juice crystals, tea bags and instant hot chocolate round out the menu. This works out to roughly 1 kilogram of food per person per day.

On long trips food makes up the heaviest item in a backpack that weighs up to 30 kilograms and when travelling through rugged terrain it is only possible to carry about a week's supply of food at a time. In order to complete these trips it is necessary to cache food at intervals along our intended route, using an airplane or helicopter. Helicopters are best for the job since they can land anywhere to place a food cache, but they are more expensive, especially in more remote areas where long flights are required. The less expensive choice is to toss the food out of a low-flying airplane onto a high snowfield. This was a common practice before helicopters became more available and is well suited to long summer traverses. We often combined airdrops with our flight up an inlet and it usually cost us only a few hundred dollars each.

The most popular bush plane on the coast is the de Havilland Beaver on floats. Though it was designed at the end of World War II and production of new airplanes stopped in 1967, it is

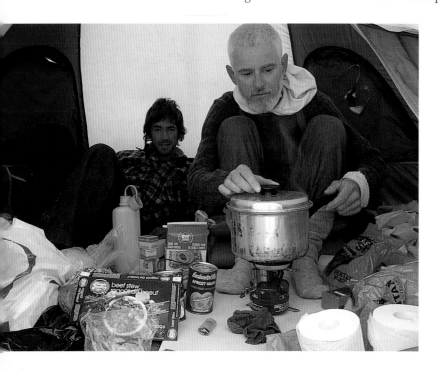

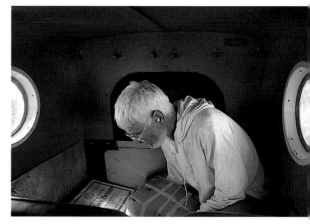

Left: John Clarke and the author preparing to feast on canned food at an airdrop on the Homathko Icefield.

Above: John Clarke holds a box of food as he peers through the hatch in the rear of a Beaver, waiting for the signal to make an airdrop.

still the most popular commercial float plane and has been dubbed "the world's greatest bush plane." (The history of the Beaver has been chronicled by Sean Rossiter in *The Immortal Beaver*.) For us the Beaver is the best plane for doing airdrops because of its carrying capacity and a built-in hatch behind the cabin's rear seat. The basic idea of an airdrop is simple, but attention to detail is essential to ensure that the food survives the drop. All our food is triple bagged and packed tightly in cardboard boxes lined with plastic garbage bags. The boxes must be small enough to fit through an 18-inch-diameter hatch in the plane and we wrap them three times in every direction with fibreglass tape. White gas is packed in 1-litre oblong cans with screw-on lids, taped two to a bundle and wrapped in cardboard. We drop twice as much white gas as we need.

Airdrop sites are chosen carefully. The best ones are high, wide snowfields with lots of room for the airplane to circle over the snow and then swing back over a deep valley after making the drop. One of us sits beside the pilot checking maps and the other stands over the hatch behind the back seat, looking out at a bewildering jumble of trees, rocks and snow. On a prearranged signal from the person in the front, the other tosses the boxes through the hatch as fast as possible.

Watching the boxes hurtle out of sight it is difficult to imagine that anything could survive the drop. On the best drops the pilot is able to cut the airspeed to under 100 km/hr and fly in over the airdrop site only 40 metres above the snow. At other sites, with poor approaches (or sometimes a nervous pilot), the plane can be several hundred metres above the snow and still flying at 150 km/hr when the boxes are tossed through the hatch. The success of an airdrop is not discovered until one or two weeks into a trip. We always feel considerable anticipation as we walk up the last stretch of snowfield, half expecting to see food splattered all over the area. The boxes do get banged up on impact, but most of the time they just tumble to a stop on the soft summer corn snow, with little damage to the food.

Bottom: A CoVal Air Beaver at the head of Bute Inlet. For longer summer trips, we place boxes of food at intervals along our intended route by dropping them on high snowfields from helicopters or planes.

Below: A box of food after it has been dropped from the air onto the snow.

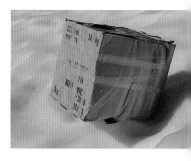

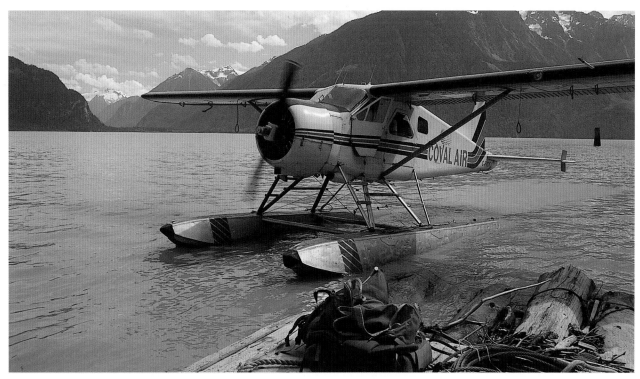

Over the years there has been the odd mishap, however. If the snow is too hard the individual bags of food break open inside the cardboard box so that bits of rice get mixed in with the oatmeal and the dried fruit gets covered by lentils. This kind of mishap is reasonably easy to live with. But on one occasion, two of the boxes broke open and food was splattered over the snow. By the time we reached the airdrop, bloated raisins and nuts had melted into the snow and we had to chase away a pair of ravens who had claimed this great find as their own! Luckily there was still enough food left for the rest of our trip. Another time we got our first glimpse of an airdrop from a mountain above the designated snowfield. At first glance everything looked fine, but when we counted the dots on the snow there seemed to be one more box than we had dropped. It was not until we walked right up to the airdrop that we realized what had happened. There were four pieces of cardboard on the snow (instead of three boxes) and absolutely nothing else, except a single tuna tin that had been chewed for so long that there wasn't even a whiff of tuna left. Beyond the last of the cardboard boxes were several enormous piles of grizzly bear droppings! We stared in disbelief. The airdrop was necessary for the last week of a long traverse to Owikeno Lake. Since we now had only one dinner remaining, we quickly realized we had to keep going. The question was, which way? Luckily an exit route was available. We quickly headed down the closest valley, the Chuckwalla River, and picked up an old road that led to a logging camp on Rivers Inlet and food!

Most of our airdrops worked well, but the odd mishap occurs. These boxes (below right) were dropped at a poor site and were badly damaged on impact. On another occasion a grizzly bear ate our entire food drop, except for a few pieces of cardboard and a single tuna tin that had been chewed for so long that there wasn't even a whiff of tuna left (below). The bear also bit open each of our 1-litre gas cans (bottom left).

Opposite: Icebergs drift in glacier-fed Clendenning Lake. Long moraines on the Clendenning Glacier wind out of sight in the distance.

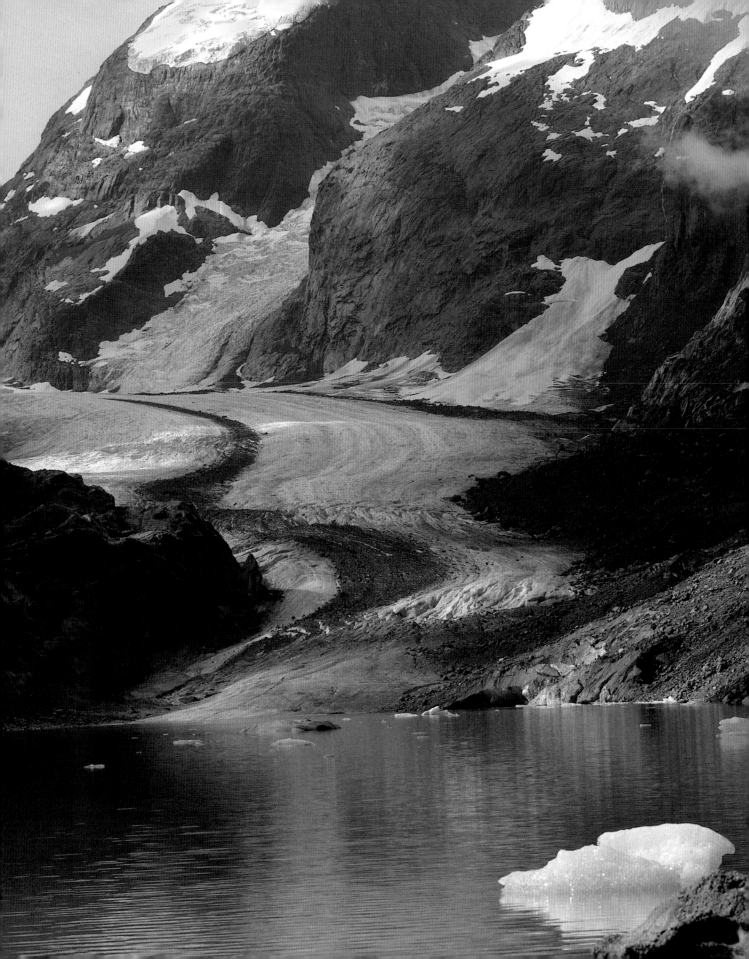

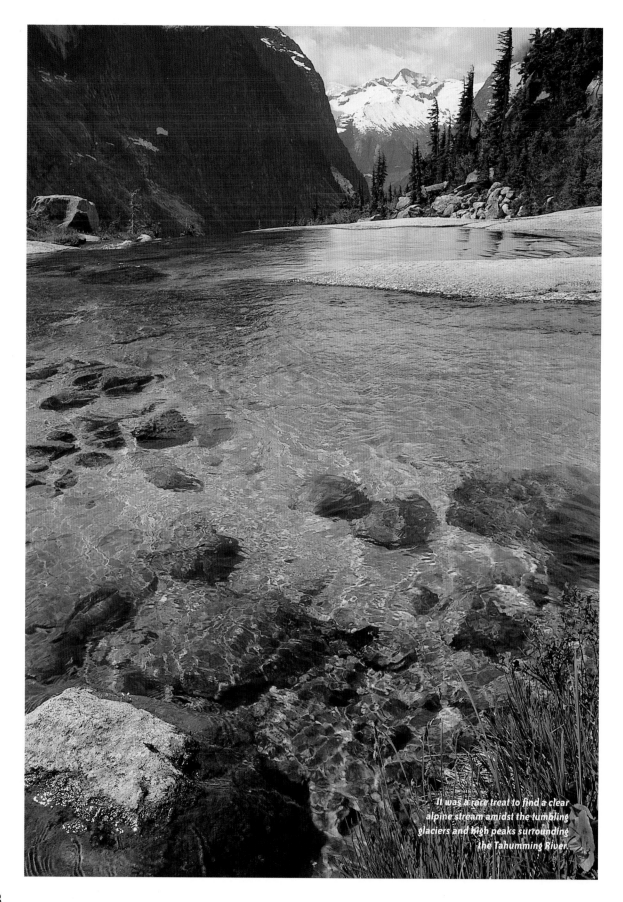

It was a rare treat to find a clear alpine stream amidst the tumbling glaciers and high peaks surrounding the Tahumming River.

Though grizzly bears abound in the deep coastal valleys and are common in alpine meadows on the interior side of the range, it is extremely rare to see bears in the alpine on the coast. This is partly because the alpine is difficult to reach but also because there is little to entice a bear. This holds true for other animals as well, so viewing wildlife is generally not a big part of a trip into the high mountains. The only exception on the coast is goats, which seem to thrive on these high ridges and can be seen fairly often tramping across glaciers and steep slabs to seek out tiny isolated patches of grass. Goats are amazing animals, almost cowlike in their manner, yet extremely strong and agile. At intervals during the day they rest in depressions in the earth. These "beds" are usually located near a ridge crest or promontory, where a gentle breeze keeps bugs out of the goats' faces. On rare occasions it is possible to sneak up on the animals and if the wind is blowing your scent away you can get quite close for a photograph. Goats startle easily but one gets the feeling that they don't feel that threatened on these high coastal divides. From their look, it is clear that they don't understand what people are.

On one occasion we came across a billy, a nanny and a kid. With the wind in our favour we dropped our packs and moved closer. We were in plain view and the goats could see us clearly but since they didn't seem uncomfortable we moved toward them slowly until we were within 10 metres of the nanny and kid. At this point the billy goat walked right up to us and stared. It wasn't clear how he was reacting, but after about a minute he seemed to decide that we were not a threat and went back to the nanny and sat down. We immediately sat down as well and the family settled back to their business, still aware of our presence but not so worried that the nanny couldn't feed the kid some milk. Regrettably, after fifteen or twenty minutes it was time to leave, as we were low on food and had to continue to our destination.

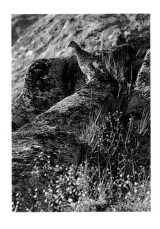

Above: Ptarmigan are occasionally seen in the alpine.

Below: Mountain goats near the Tahumming River spend their summers in the high alpine searching out small patches of meadow amidst the heavily glaciated peaks.

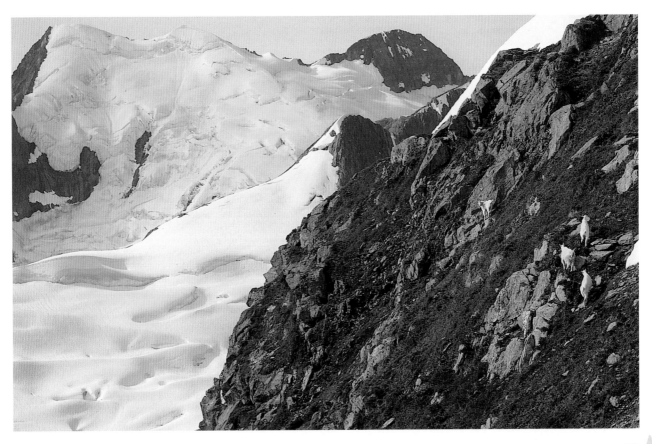

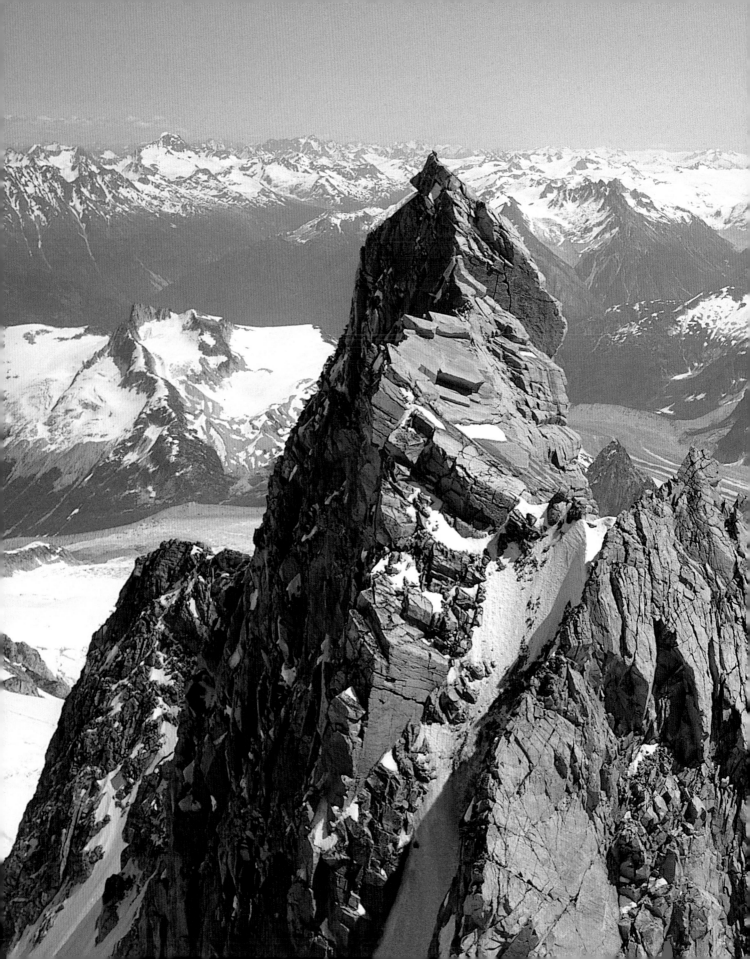

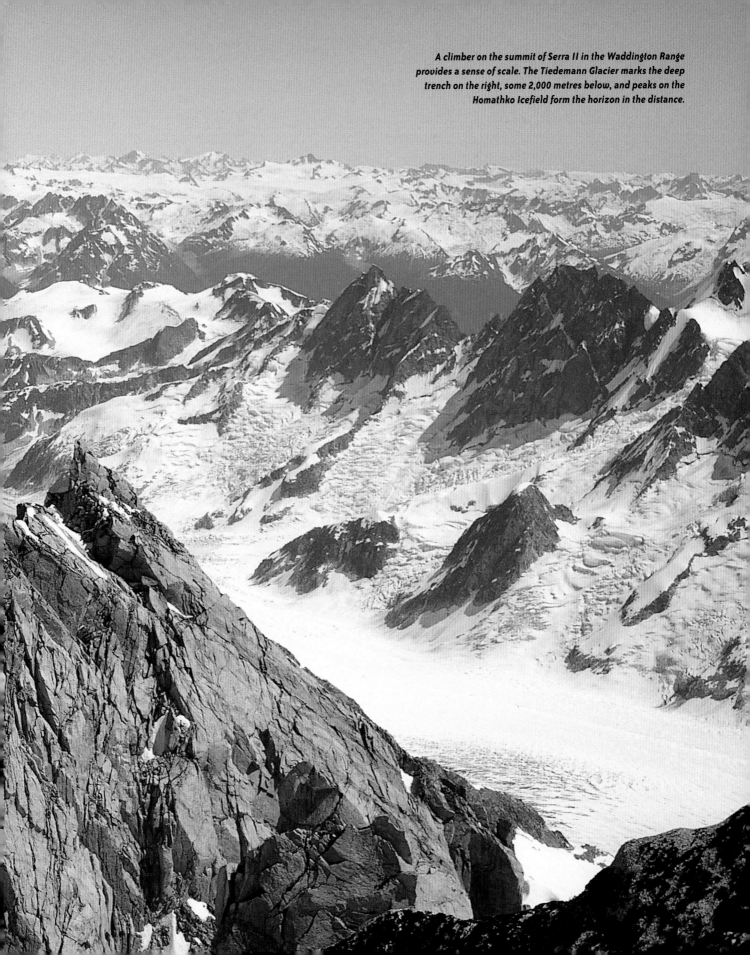

A climber on the summit of Serra II in the Waddington Range provides a sense of scale. The Tiedemann Glacier marks the deep trench on the right, some 2,000 metres below, and peaks on the Homathko Icefield form the horizon in the distance.

*John Clarke poses on Peak 7412 — an unnamed summit west of South
Bentinck Arm. Many summits often require some scrambling on steeper
rock, but very few require difficult roped climbing.*

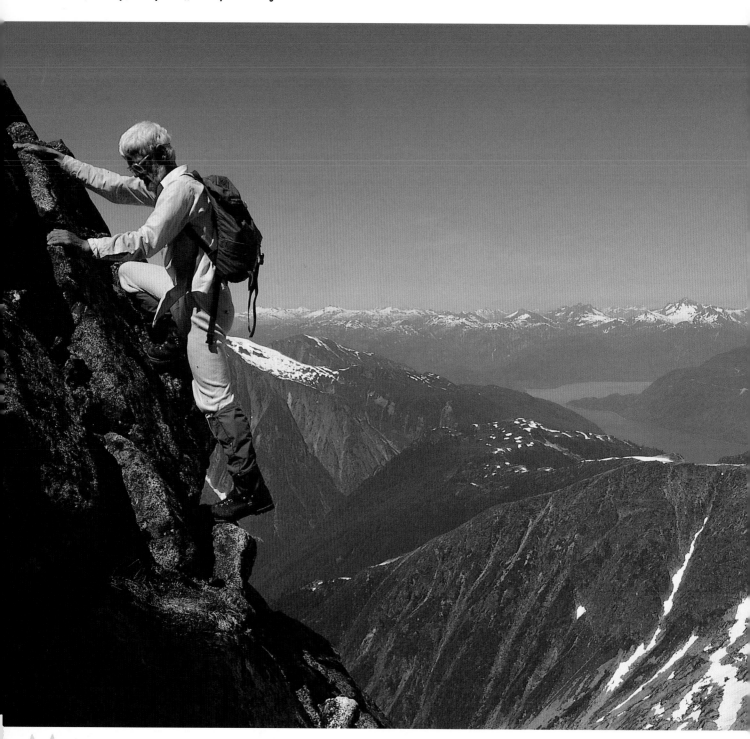

Left: In mountaineering tradition we build a cairn of rocks to celebrate the first ascent. Usually no more than a few rocks piled together, the cairn sometimes finds particularly zealous expression, as did this one on a peak above the Tahumming River.

Below: Late afternoon sun highlights a heavily crevassed glacier south of Tumult Creek at the head of Knight Inlet.

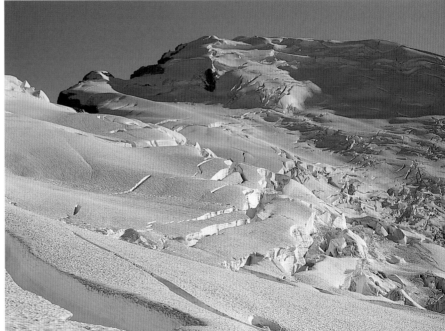

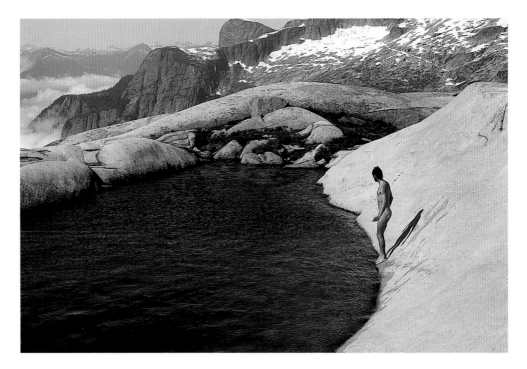

Right: The author enjoys a dip in an Olympic-sized tarn above Princess Louisa Inlet. Photo by Eda Kadar.

Below: A waterfall cascades down a broken cliff.

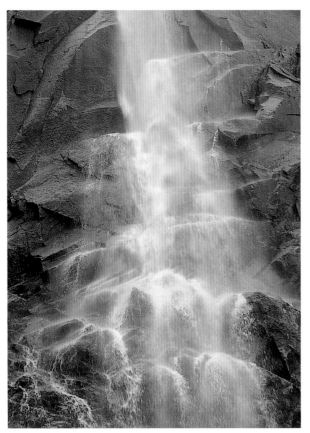

It is strange how one trip leads into another. Somehow this had all begun many years ago, when I was a child in Vancouver, gazing up at the southern end of a range of mountains. Without any particular plan, summer after summer had found us journeying to some remote inlet. Our progress had been somewhat haphazard but had generally taken us to the northwest. Slowly we left the higher peaks behind, far to the southeast. On a trip from South Bentinck Arm I remember reaching the farthest 1,950-metre summit on the Clyak Divide, where we found ourselves looking out not to more mountains on the horizon, but to the Pacific Ocean, dimly visible through the afternoon haze. We almost felt that this summit was the culmination of our years of climbing.

Like those before us, we had not found the northwest passage. But now we realized that it was the looking for it that mattered. It is only when you are looking that the goats and tarns, the glaciers and meadows, and the mist and the fog can seep into your bones. And only then can you realize just how deeply you are connected to these endless miles of nameless mountains.

On another trip to Wahkash Peak I remember looking out at the sea of mountains around us. To the north we saw Mt. Stanton and Whitemantle Mountain marking our route. Mt. Waddington was just beyond, but my eyes were drawn to the maze of peaks and rows of lower summits that stretched along the entire outer fringe of the Coast Mountains. It was strange to realize how familiar to me these wild remote summits had become. What had once been unknown and had formed such a driving force behind many of my previous trips was now an inseparable part of my being. But not only had the mountains become part of me, I had become part of them in some way, and I could see myself in them in much the same way as you see yourself when you look in a mirror.

A shaft of sunlight shines on a western trillium.

John Clarke meanders down huge slabs of bare rock above an unnamed lake on the west side of the Tahumming River.

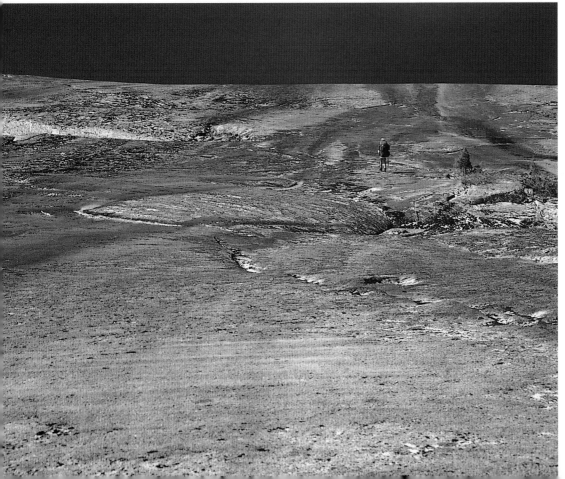

65

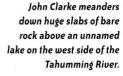

The end of a trip cannot always be planned as carefully as the start because of weather and uncertainties about the route. As the mainland coast is mostly uninhabited, remote logging camps at the heads of the long inlets are the only way to return to civilization. Logging roads run up most of the major river valleys on the coast and offer exit routes to the camps. Reaching these roads from the alpine, however, is not always straightforward. An example of this was our exit from a trip to the mountains behind Thompson Sound in 1988. In my journal I wrote: "The rain continued for the next few days and any hopes of our completing the traverse around the Kakweiken drainage were abandoned and an exit to Kingcome Inlet became the most obvious way to use our remaining supplies of food. We had spent the last two and a half weeks staring into these wild valleys from above. Now we would see them face to face. Over the next two days we picked our way between missing contours amidst echoes of waterfalls rising from the fog below. It rained continuously. At one point we lowered ourselves down a small cliff on the long branches of slide alder that somehow grew there. In the valley bottom the usual head-high ferns and salmonberries greeted us. When the rain stopped we rested in an opening cleared by avalanche debris. Above rose a tremendous waterfall. This was the upper Atlatzi valley, and the feeling of remoteness it evoked was more powerful than the alpine could ever be.

As the mainland coast is mostly uninhabited, our return to civilization at the end of a trip is often to a remote logging camp at the head of a long inlet. Here, two climbers walk into Scar Creek camp on the Homathko River.

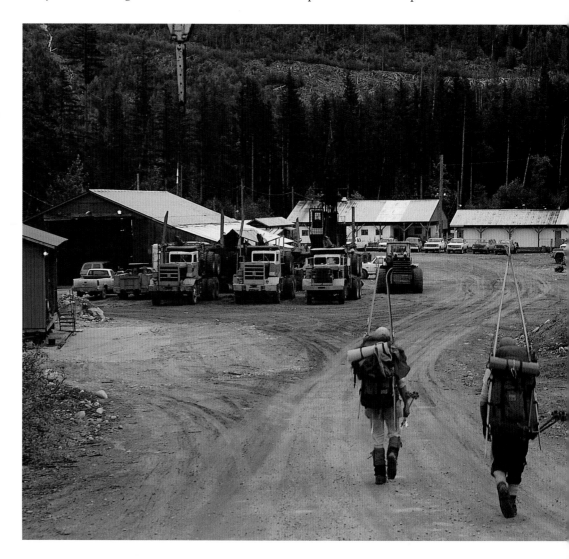

There were no pretty little flowers and neatly trimmed meadows here; everything was bold and dramatic. A thick layer of moss grew on everything and with much effort we managed a fire under a spruce tree. Our cameras and sleeping bags were the only things that were dry."

Eventually we do pick up a road and follow it to a logging camp at the head of an inlet. The loggers carry on their work near these remote camps, surrounded by mountains and cut off from the rest of the world except for a daily supply plane. The arrival of anyone other than a logger is unusual; the arrival of someone on foot is unheard of and is usually greeted with inquiries such as: "Is this some kind of holiday or something?" After our reply, they often say, "On my holidays, I get out of this place!" They usually offer us showers, and make arrangements to put us on the next plane out.

As we board the small float plane for the flight home our transition to the outside world begins. We leave the shores of the inlet behind and the plane flies down the narrow waterway surrounded by the mountains we have come to know so well. After weeks on foot, it feels odd to move through the mountains so quickly with so little effort. The shining channels pass beneath us and the mountains drift by, slowly receding into the distance. There is a beauty here that can be mistaken as harsh and lonely, but the feeling that it leaves is not.

Logging camps are reached by small planes from Vancouver Island or Bella Coola. The photograph above shows John Clarke and me waiting on the dock at Kingcome Inlet for a float plane to pick us up. While drying our gear in the sun, we spotted a salmon wedged between piles behind the dock. The fish was exposed as the tide fell (top), and was still fresh. Later it became a present when we were invited up to see the Indian village on the Kingcome River.

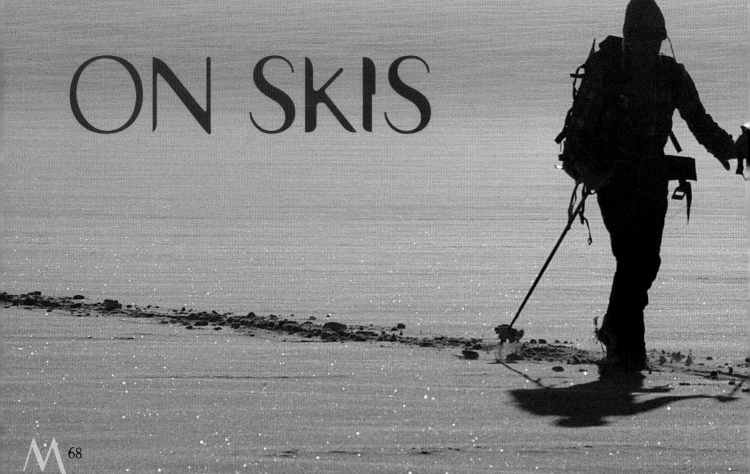

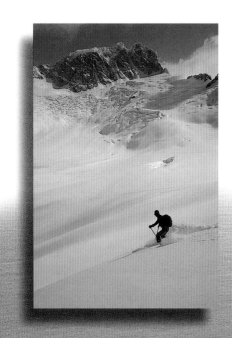

The backbone of the Coast Mountains is marked by a string of icefields that surround the highest summits.

Part Two

ON SKIS

Each winter for the past twenty years I have dreamed about these icefields, planning a May ski trip into this wild snowy landscape. With the passage of each new winter storm I would imagine snow filling in dangerous crevasses. I would imagine the smooth expanses of snow, the wild turmoil of peaks, and a ski route traversing the heart of this icy landscape. These large glaciers and icefields are remnants of the last ice age and provide natural ski routes that can be followed across vast sections of the Coast Mountains. But through an odd twist of geography, the extent of this glaciation is rarely visible from low-lying areas. Indeed, few people are even aware that large glaciers lie within commuting distance of downtown Vancouver and icefields stretch north for hundreds of kilometres.

Inset, opposite: Steve Ludwig skiing on the slopes of Mt. Cavalier, below the south face of Mt. Waddington.

Opposite, bottom: Peter Stone silhouetted against the morning sun on the Monarch Icefield.

Inset, below: A wintry camp in early May, high on the Waddington Glacier, with the Whitemantle Range beyond.

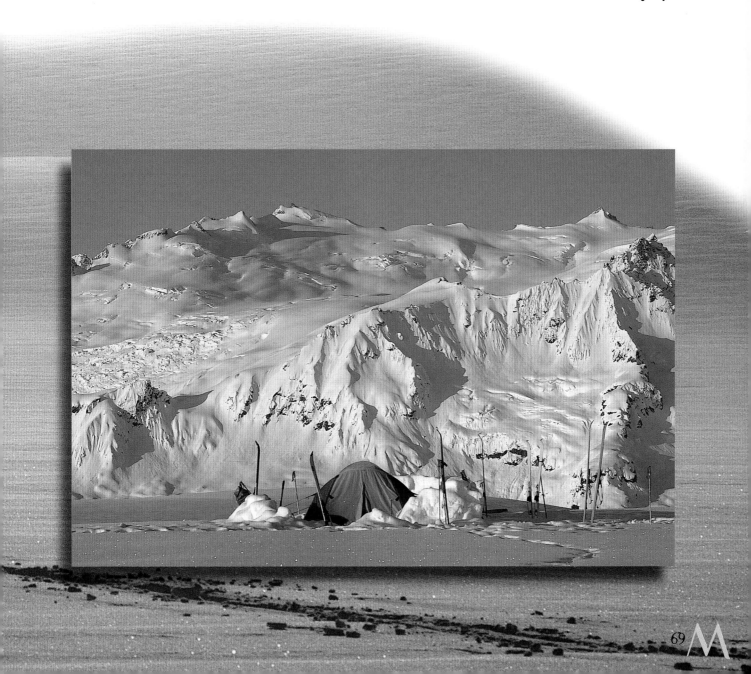

My interest in visiting these large icefields began in 1979 on a spring ski touring trip to the Manatee Range at the southern end of the Lillooet Icefield, the first major icefield north of Vancouver. Access roads had just been built into the area and a detailed topographic map of the region had only recently been published. Part of the Lillooet Icefield happened to be on the same map sheet as the Manatee Range so in the evening, while poring over the map for the next day's route I would often glance up to the huge glaciers at the centre of the icefield and wonder what they were like. This curiosity evolved into the idea of crossing the Lillooet Icefield on skis. The following year, in 1980, with friends from university I organized a three-week ski traverse across the Lillooet Icefield from the Tchaikazan River on the interior side of the range to the Manatee Range.

That traverse was the first of a series of annual trips to one icefield after another. Many of them followed the same pattern: each trip traverses one of the major icefields often crossing the full width of the Coast Mountains. This is usually a journey of two to four weeks through a

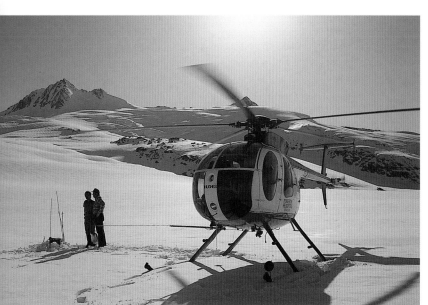

Food caches dropped at intervals along our intended route are marked with long bamboo wands.

wild maze of peaks and glaciers. Route finding is critical, hence trips must be planned carefully beforehand to avoid dangerous icefalls and areas of extreme avalanche hazard. Food caches, placed at one-week intervals along the route by a helicopter, are marked with long bamboo wands. Without exception May is the best month to travel. Spring weather is more stable and by then the most violent of the winter storms have ended. The spring snowpack is also less avalanche-prone and many crevasses are safely filled in from the full depth of winter snow. We use metal-edged touring skis along with insulated leather boots. Cross country wax or skins strapped to the bottom of our skis provide grip when climbing uphill. Most trips were completed with two or three friends, often Steve Ludwig and Helen Sovdat, but also John Clarke, Gordon Ferguson, Stan Sovdat or others.

Our idea for a ski traverse was not a new one. Ski traverses had originated in Europe along high alpine routes through the Alps and the mountains of Scandinavia. They were introduced to North America in 1958, when a group of mountaineers skied from the Bugaboos to Rogers Pass in the Selkirk Mountains of BC. Other ski traverses in the Rocky Mountains followed. The thrill of crossing a high mountain range on skis was aptly described by one of the pioneers of these routes, Hans Gmoser: "A man should have wings to carry him where his dreams go but sometimes a pair of skis makes a good substitute."

Skis had been used on the large icefields of the Coast Mountains as early as 1929 but it was not until the 1960s that local climbers seriously contemplated an alpine traverse through the high mountains. The first ski traverse to be completed in the Coast Mountains was a high alpine route through the Spearhead Range in 1964, from the mountains that would later be home to Whistler and Blackcomb ski resorts. Other traverses followed and a few of them branched out across the larger icefields farther north. Local skiers, however, were slow to realize the potential for long alpine ski routes in the Coast Mountains, and only a few routes were completed prior to 1980.

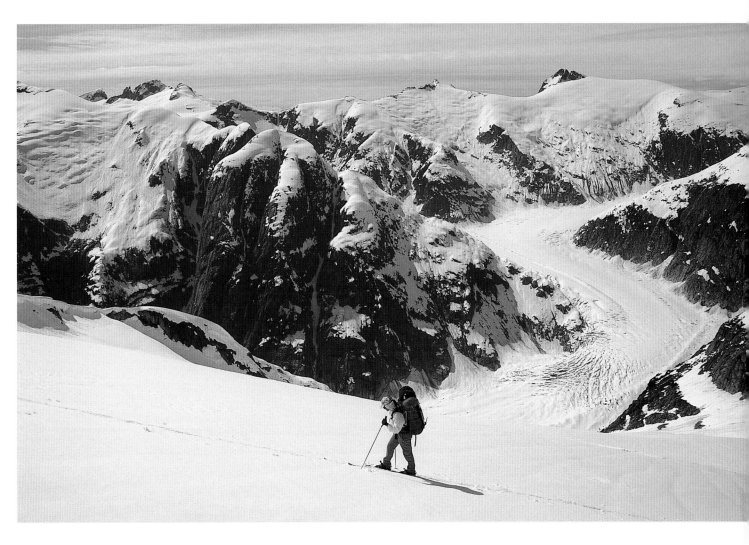

Above: A lone skier is dwarfed by the massive trench of the Satsalla Glacier draining the Ha-iltzuk Icefield.

Left: Winter snow flutings on Ossa Mountain in the Tantalus Range.

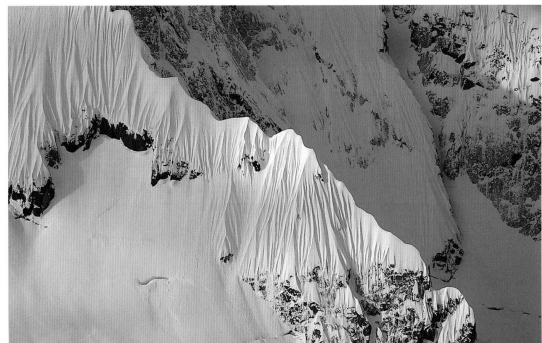

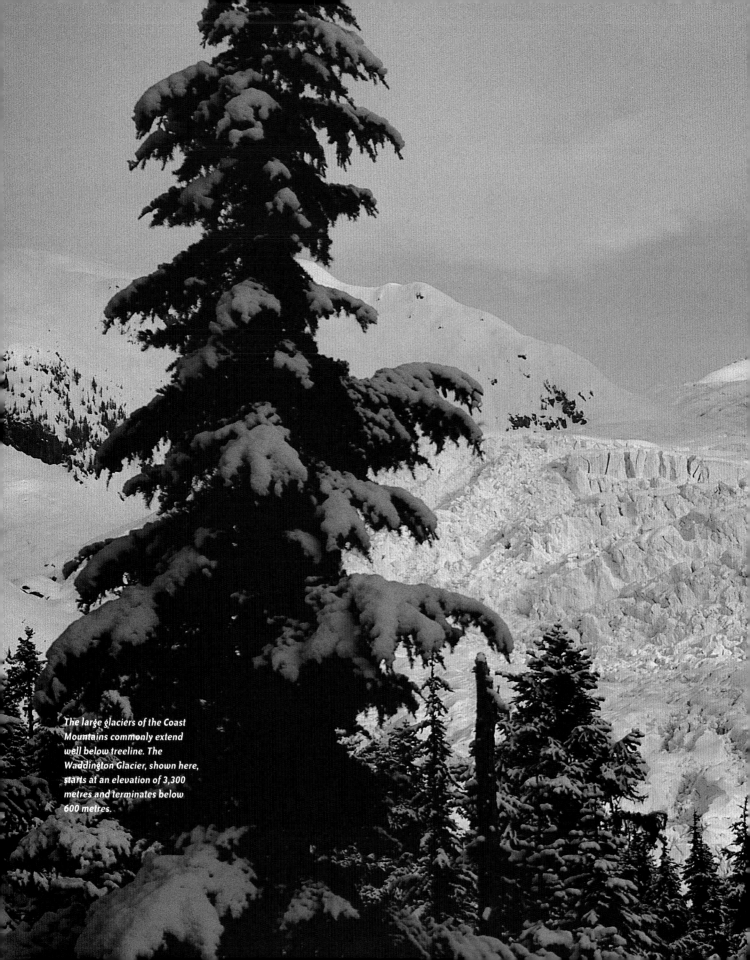

The large glaciers of the Coast Mountains commonly extend well below treeline. The Waddington Glacier, shown here, starts at an elevation of 3,300 metres and terminates below 600 metres.

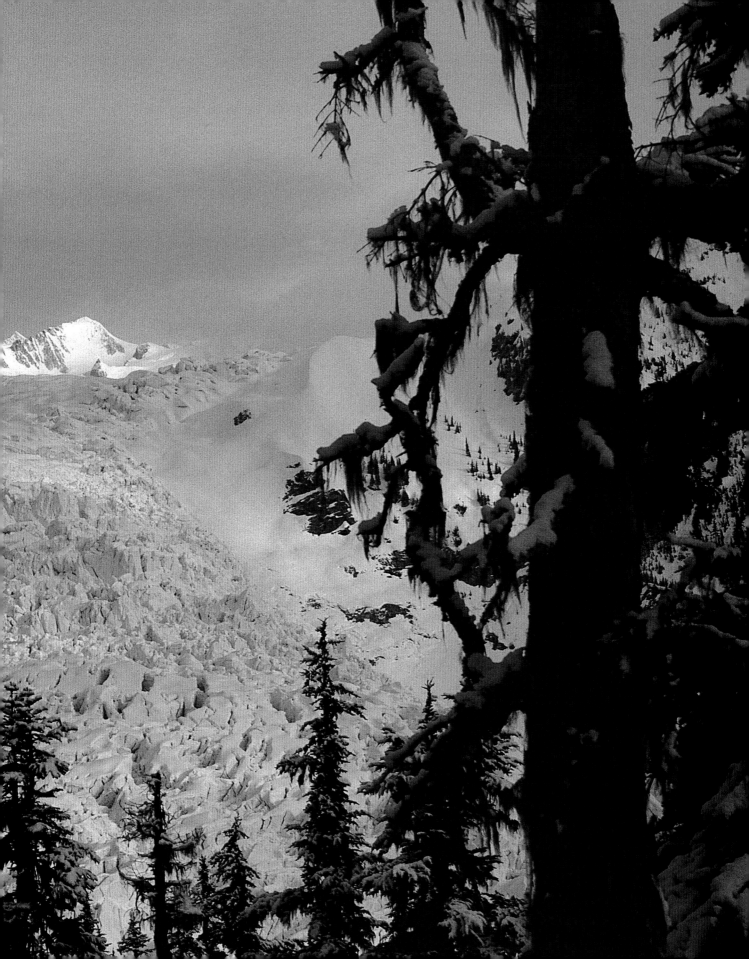

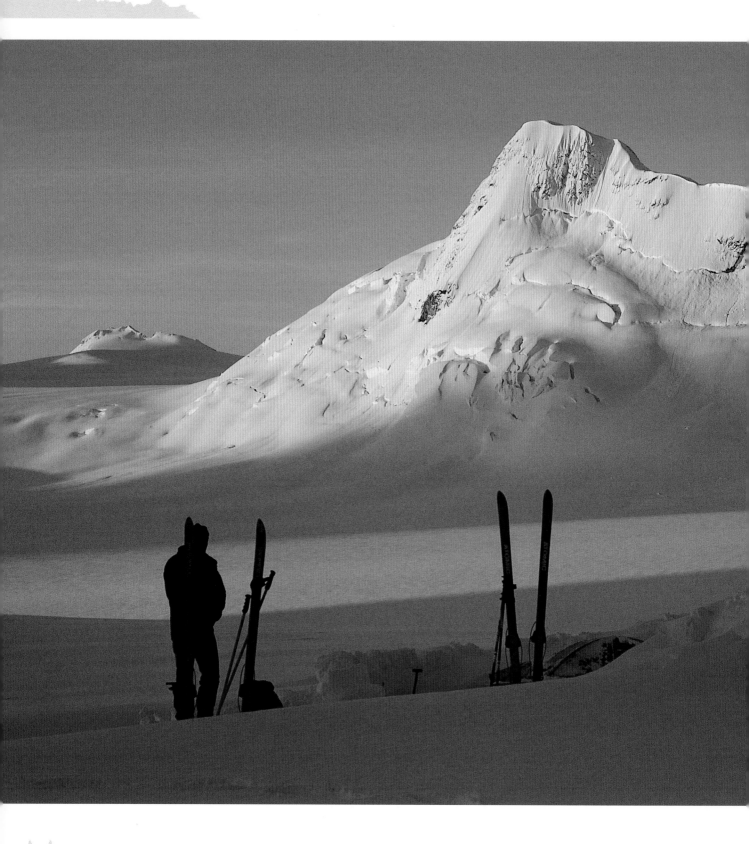

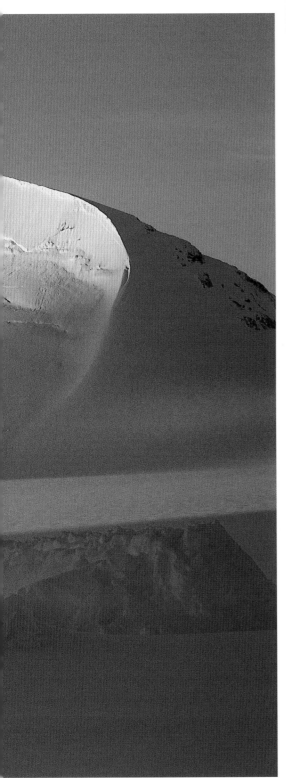

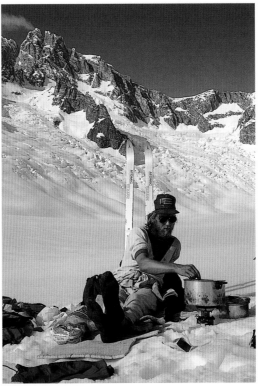

Opposite: After a five-day snowstorm we eagerly rise early to catch the first rays of light on Mt. Satan on the Monarch Icefield. Our buried tent is just visible behind the pair of skis at right.

Left: While cooking dinner, Brian Sheffield enjoys a warm evening on the Corridor Glacier in the Waddington Range.

Below: Modern lightweight mountaineering equipment is crucial on these trips. Here we turn our tent toward the sun to dry the floor before packing up for the day.

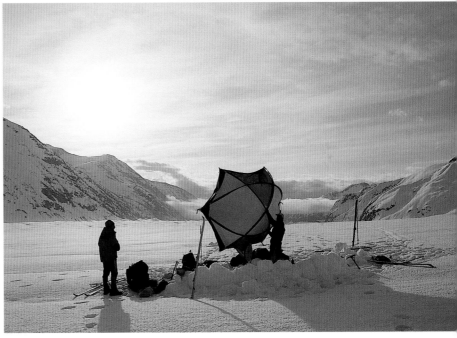

Thus on many of my first trips we knew relatively little about what to expect. We usually started on the interior side of the range where access is generally easiest from the Chilcotin, and finished on the coast at one of the major inlets. We slowly worked our way up one of the broad subalpine valleys with heavy packs. On such a trip it is often necessary to carry skis for the first day because the snow has already melted from the lower parts of the valley, earlier than on the coastal side of the range. There is relatively little underbrush in these valleys but the skis still catch on branches. Vague game trails, sparse pine trees and the fresh buds and colours of spring eventually give way to patchy snow. In the alpine the bleak appearance of glacial moraines and windswept snow give these valleys a lonely, barren feeling typical of the interior side of the Coast Mountains—an impression that belies the relative friendliness of the terrain. Day by day a route through the apparent maze of mountains unfolds and their stark beauty is gradually revealed. Once in the alpine we rarely drop below treeline, and it is common on these trips not to see a single tree for three or four weeks. Bears are usually coming out of hibernation at this time and it is common to see grizzly tracks in the snow. On one occasion I saw a set of tracks where the bear had taken a detour to slide down a steeper snowslope on his bum.

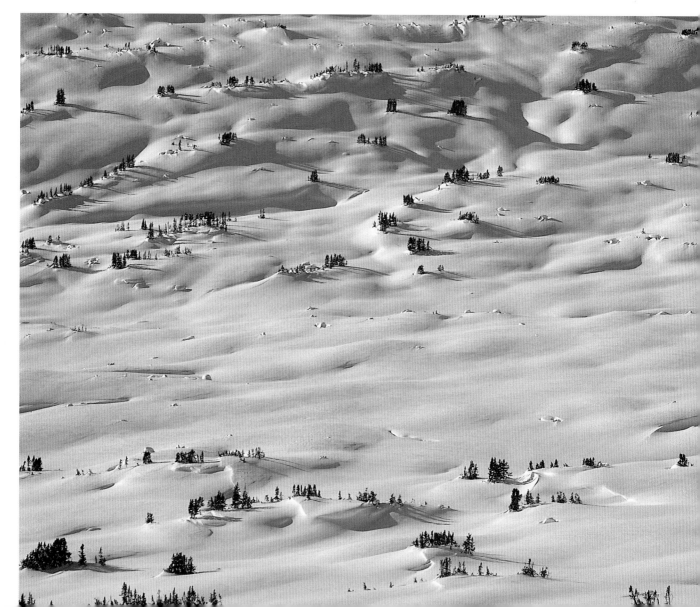

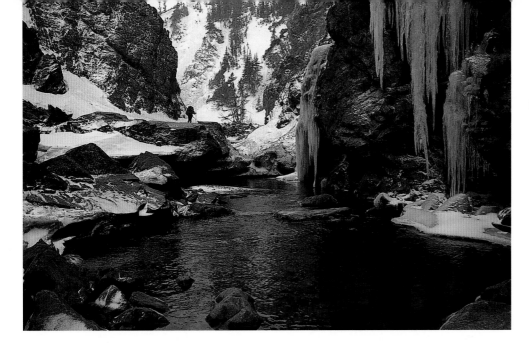

Left: Many of my first ski trips started from the interior side of the range, where access is reasonably easy. Here, John Clarke skis around an open pool in Stikelan Creek on a traverse across the Homathko Icefield. Though it is late April, the long icicles indicate that winter is not yet over.

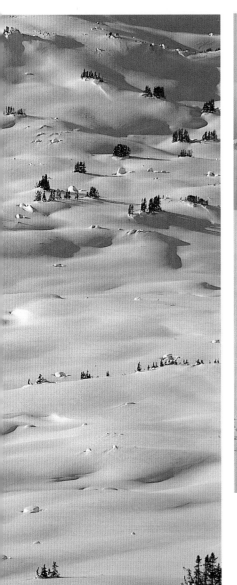

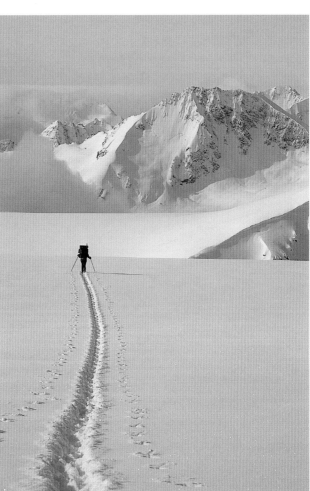

Opposite, top: Grizzly bears generally come out of hibernation by early May, and it is common to see tracks in the snow as the bears head for lower elevations in search of food. These tracks are particularly interesting because you can see where the bear purposefully slid down the steep snowslope on his bum.

Opposite, bottom: Lush alpine meadows take on an abstract form in early spring.

Left: John Clarke heads south onto the Ha-iltzuk Icefield.

77

Below: The first views of distant summits give a hint of the route ahead for the coming weeks of a long traverse.

Bottom: Gordon Ferguson traverses under an icefall in the Whitemantle Range.

Gradually the high alpine valleys give way to longer glaciers surrounded by cliffs and tumbling icefalls, and eventually we climb onto one of the large icefields that lie near the centre of the range. From the icefield we make side trips to climb mountains en route. The first view from a peak is always special. The rugged, youthful vigour of the sharp peaks and surrounding icefalls is juxtaposed against the tranquillity and age of the smooth icefields. The scale of contrast is overwhelming: flat against steep, white against blue, smooth against broken. There is incredible turmoil, yet the scene is at once restless and still.

Usually we are able to pick out a distant summit that lies at the far end of our traverse three or four weeks away, and it is only then that the imaginary route carefully worked out on the map begins to take on its full size! We fall into a regular pattern of moving camp each night on a slow, steady progression to these distant landmarks. We ski up over high passes, down past icefalls and across vast expanses of snow.

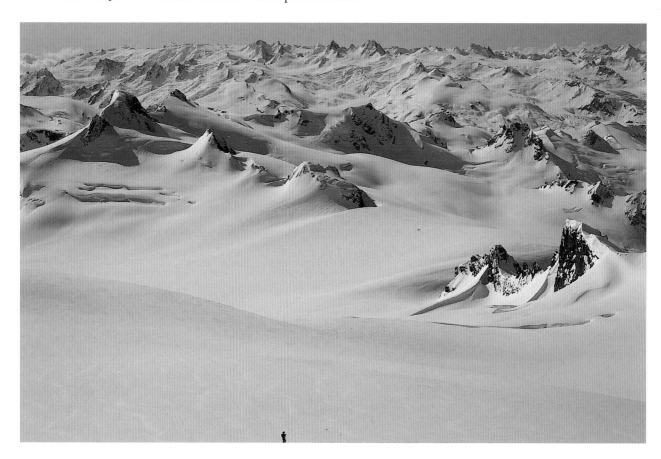

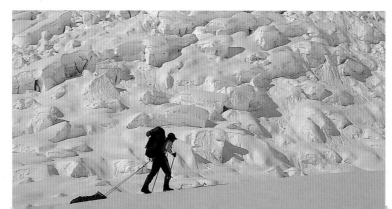

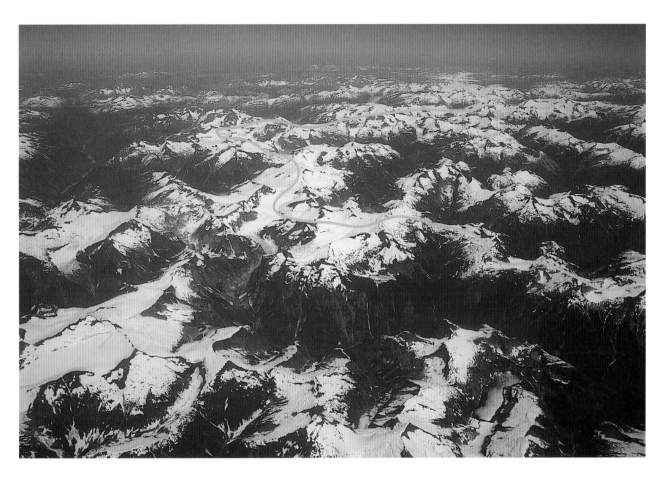

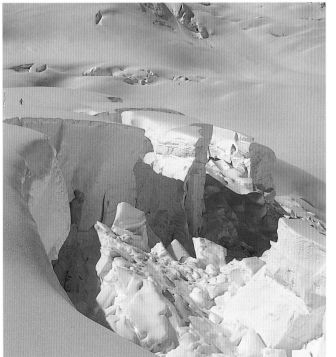

Above: Aerial view of the mountains between the Southgate and Toba rivers, with the Lillooet Icefield visible in the distance on the upper right of the photograph. Clearly shown is the kind of terrain that many of the long alpine ski traverses travel through. The route we followed on a four-week ski traverse is marked with a line.

Left: A lone skier is dwarfed by huge seracs on the Dais Glacier in the Waddington Range.

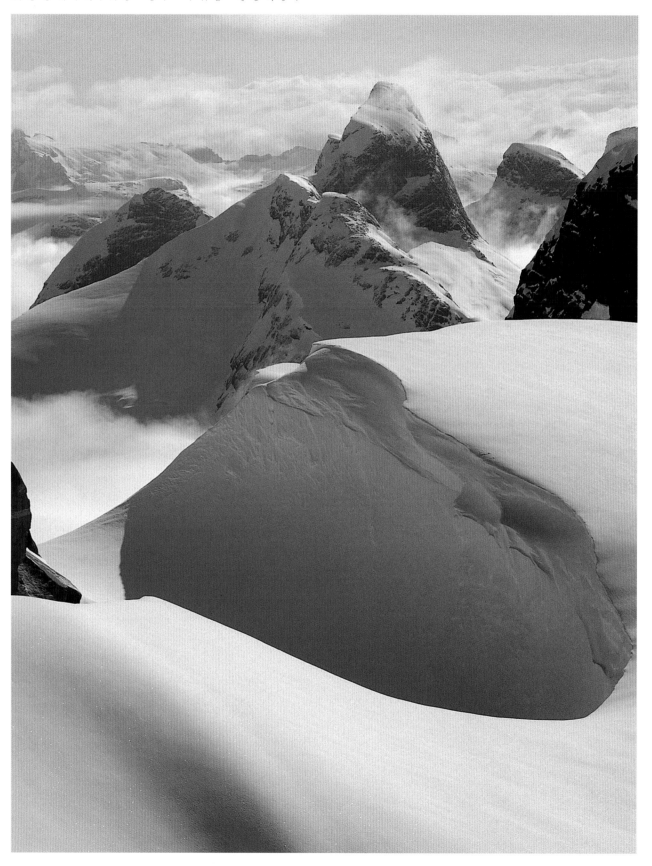

There is a special thrill to skiing in such a place that tends to make us set off in ecstasy, eager to see what each new day will bring. Like nuggets in a sandbar, the surprises appear when we least expect them: there is the sudden view of patterns in the snow over the crest of a ridge, the edge of a cornice highlighted by the morning sun or the distant view of clouds billowing up from deep in a neighbouring valley. This place is made for skis, and as each one slides effortlessly forward into the sparkling snow there is a feeling of action without movement.

In a mixture of billowing cloud, snow flurries and tall shafts of sunlight we become lost in this strange world where life breathes in only the ice, wind and changing shades of black and white. We make many side trips along our route, and as we climb to one of the summits spindrift flies in the air and our boots freeze solid on our feet. From the top we can see the huge expanse of an icefield spread out below. The snow stretches for miles to where the next drowned summit rears its rocky head out of the ice. Overhead the motion of the clouds adds to this tremendous feeling of space: sunny spots and shadows spill off the far peaks and streak slowly across the wide expanse, changing shape with the gentle curves of the icefield. There is an incredible silence about, but it is not just quiet. A powerful stillness, far beyond the mere lack of noise, resonates in the air. On other peaks we can catch the view only in glimpses through the clouds.

This effect was particularly dramatic on an ascent of Blackwall Mountain west of the Compton Nêve. We had hoped to find a view down the Southgate River, but as we skied to the south summit we were engulfed by rising valley fog. We left our skis and clambered along a narrow ridge crest toward the main summit, sending small avalanches roaring over a cliff into the fog. We caught glimpses of Blackwall's big west face covered in ice feathers. But the only thing that indicated the existence of the Southgate River was its distant roar rising from the valley depths, until for a fleeting instant the clouds tore open and we peered incredulously at the spectacular view of the river 2,700 metres below us. The scene had lasted for such a short time that it was hard to know whether it was really as incredible as it had seemed.

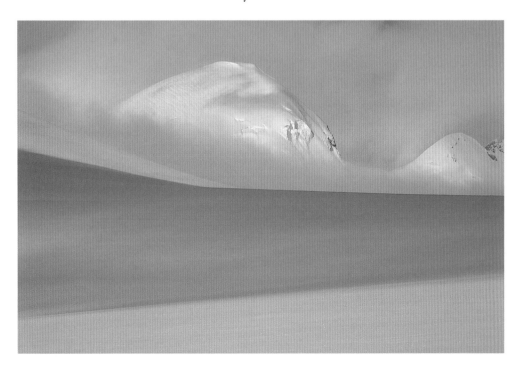

Opposite: Strong sunlight contrasts with mist and rising valley cloud on unnamed peaks at the head of the Klite River.

Above: A lone skier rests on a neck of snow between two wind cirques (large depressions in front of a rock cliff or ridge, caused by the wind scouring away the snow).

Left: Clouds often create dramatic shadows that sweep across icefields.

Below: Winter travel on a creek on the interior side of the range.

Bottom: Snow-encrusted trees against a background of wind-sculpted snow.

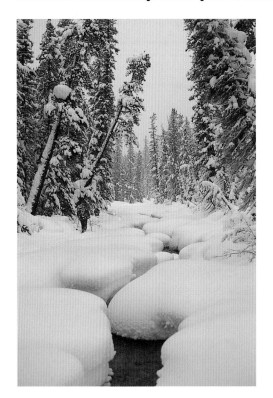

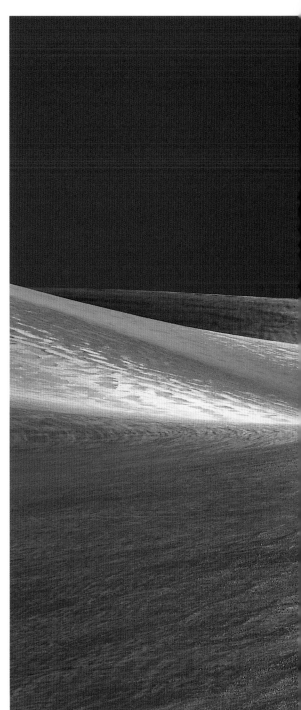

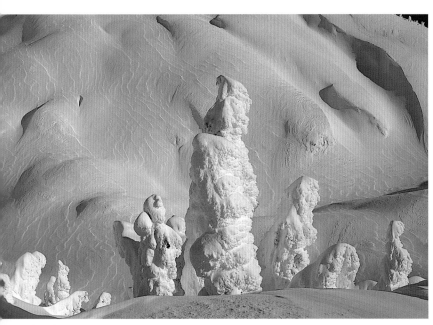

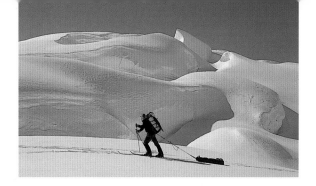

Left: Steve Ludwig picks his way beneath seracs (towers of ice) on an unnamed glacier in the Whitemantle Range, dragging a collapsible toboggan behind him to lighten his pack.

Below: A thin crust of ice on the snow glistens in the afternoon sun.

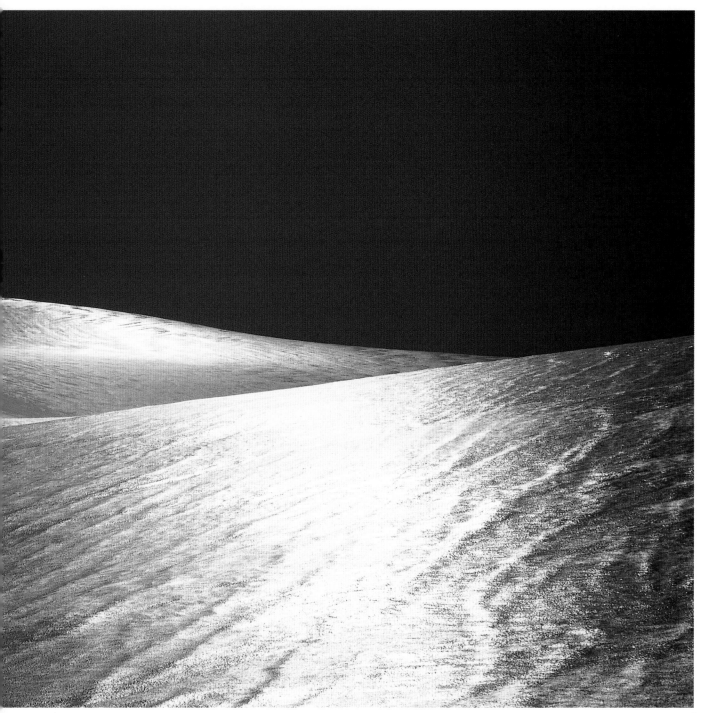

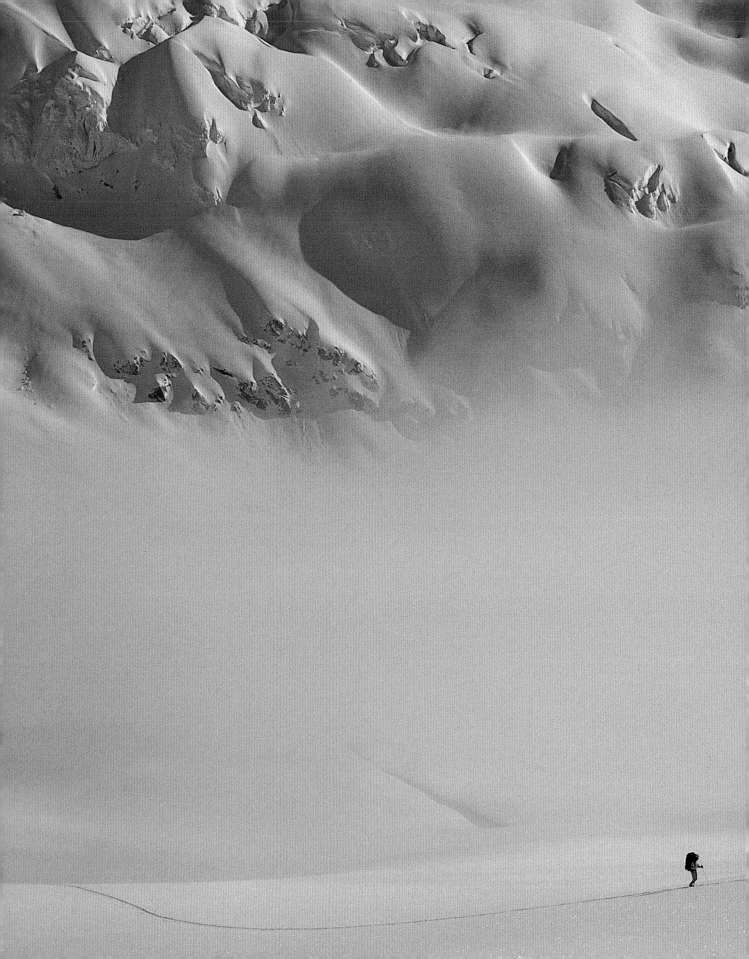

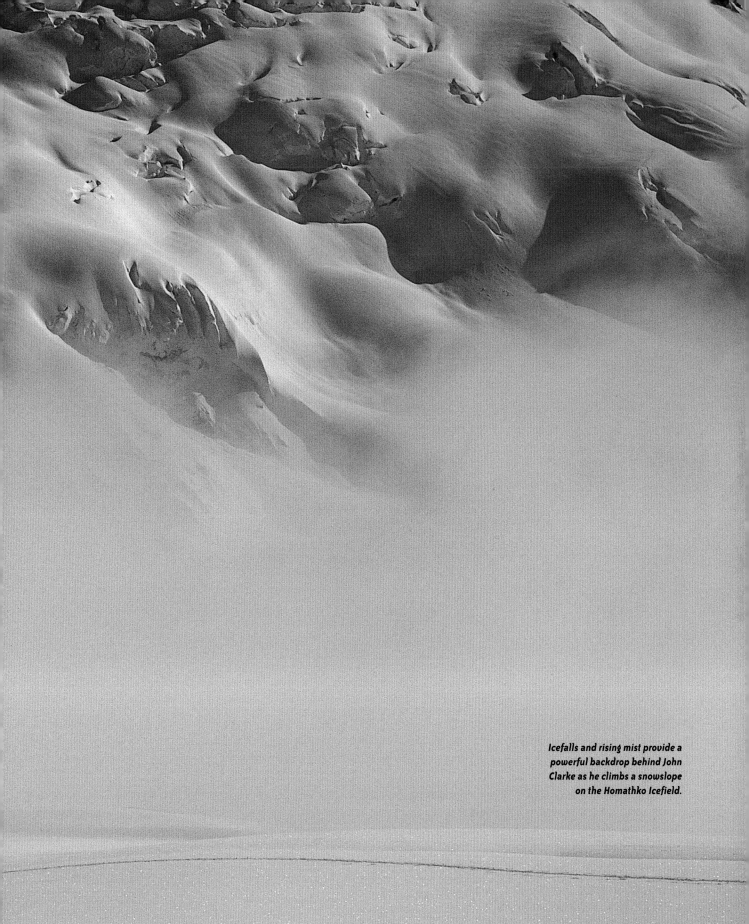

Icefalls and rising mist provide a powerful backdrop behind John Clarke as he climbs a snowslope on the Homathko Icefield.

Though most summits are only short side trips from our main route, the highest summits along the backbone of the range often require too much technical climbing for a ski trip. A few of the big peaks, however, can be climbed on skis (with sometimes a little bit of snow climbing to reach the final summit) and it is a rare treat to reach one of these on a clear day. These include peaks like Mt. Gilbert, Mt. Grenville, Mt. Munday, Zeus Mountain, Silverthrone Mountain, Cerberus Mountain and Mt. Waddington's northwest peak. They are all big peaks— the highest in their surrounding area—and all are spectacular places to be on skis. From their summits incredible views of huge icefalls and fluted ridges rise up from the surrounding snow-fields, which lie spread out below. Like the huge stretches of sand that can be seen on west coast beaches only at very low tides, these snowfields can be seen only on these rare clear days.

A lone skier is dwarfed by a heavily glaciated basin at the head of Whitemantle Creek.

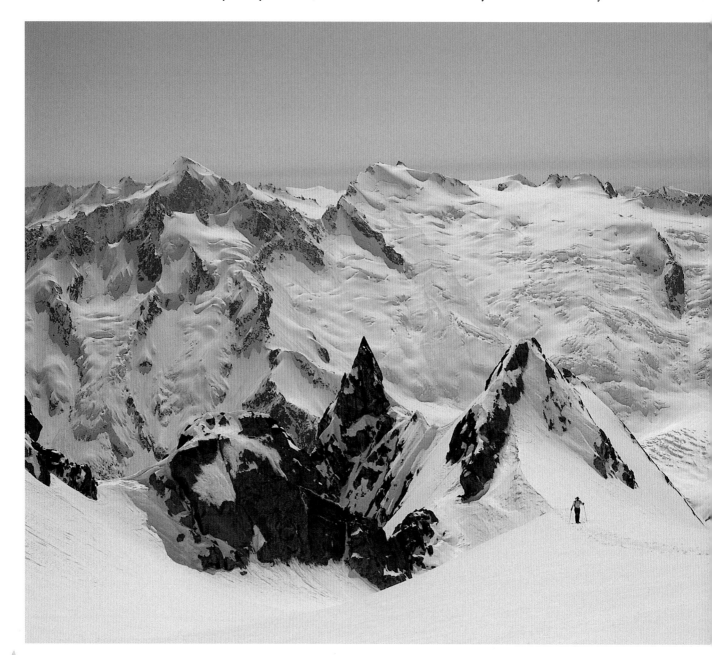

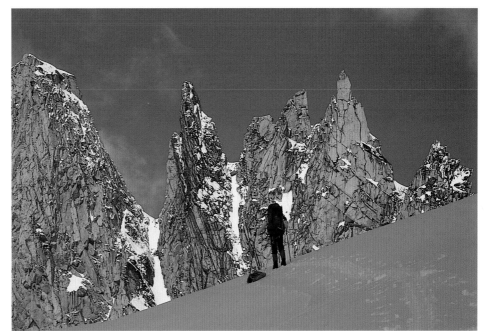

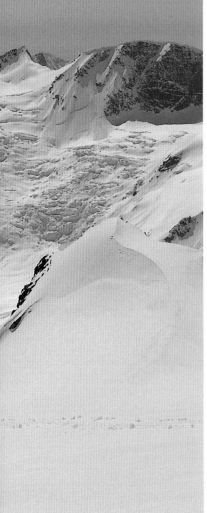

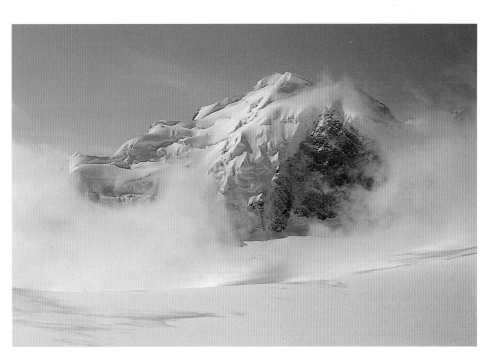

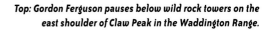

Top: Gordon Ferguson pauses below wild rock towers on the east shoulder of Claw Peak in the Waddington Range.

Above: Glaciers slop off the north face of Cerberus Mountain.

One of my most memorable big peaks was a ski ascent of the northwest peak of Mt. Waddington, which rises to within 20 metres of the main summit tower. This peak, surprisingly, can be climbed on skis via the Angel Glacier on its north side. It was not until my fourth ski trip past the mountain in 1996 that I was able to make the ascent. We had started our trip from the Homathko River and had been out about one week when our planned summit day dawned clear and cold. We packed an extra large lunch and set off. From previous attempts we had figured out how to get to the Angel Glacier from the south side of the mountain via a gully at the head of the Dais Glacier. As we broke out onto the long northwest ridge of Waddington, the distant high peaks of the Coast Mountains right up to Monarch in the northwest jutted out of a liquid level layer of clouds. We swung around to the north side of the ridge to where we could see the Angel Glacier pasted onto the north side of the mountain. This was the wild side of the peak, and blocks of ice periodically thundered down from where the lower flanks of the glacier overhung a precipice. But the route to the summit looked okay.

We jumped the bergschrund and dropped into the narrow cirque on the Angel Glacier. Trail breaking was heavy, and we began to feel the altitude. The horizon of clouds began to rise, obscuring the distant peaks, but we could still see 2,200 metres down into the deep trench of the Scimitar Glacier and the summit remained in the sun. It was after three o'clock by the time we reached the final bergschrund. We left our skis here and a few minutes later kicked steps up the last narrow snow arête to the summit with spindrift flying in the air. We took turns standing on the narrow summit. Immediately across from us stood the main summit tower of Waddington plastered in ice, and the full length of the Tiedemann Glacier was visible to the left. Though the summit looked calm and peaceful in the late afternoon sun, it was clear that it also had that storm-battered look that is duplicated only on the rocky headlands that jut out into the Pacific Ocean on the coast below. We stayed on top for almost half an hour. Steve's altimeter watch had tallied our elevation gain to the peak at 2,300 metres that day. On the way down we had to work a bit to force turns on the Angel Glacier, but it was a wild place to ski.

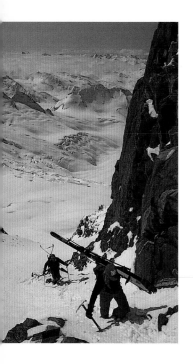

Above: Steve Ludwig and Stan Soudat carry skis up a steep snow gully at the head of the Dais Glacier to gain the ski route up the Angel Glacier to the northwest peak of Mt. Waddington.

Right: Mt. Waddington, as seen from the north with the main summit visible on the left. The Angel Glacier forms the long ramp that ascends diagonally across the north side of the northwest peak. Our ski route crossed the ridge on the far right from the Dais Glacier.

Opposite: Mt. Waddington, seen here from the southeast, towers above all surrounding summits and bears the full brunt of storms sweeping in off the Pacific Ocean.

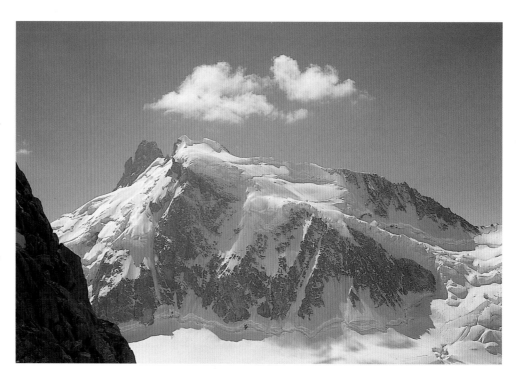

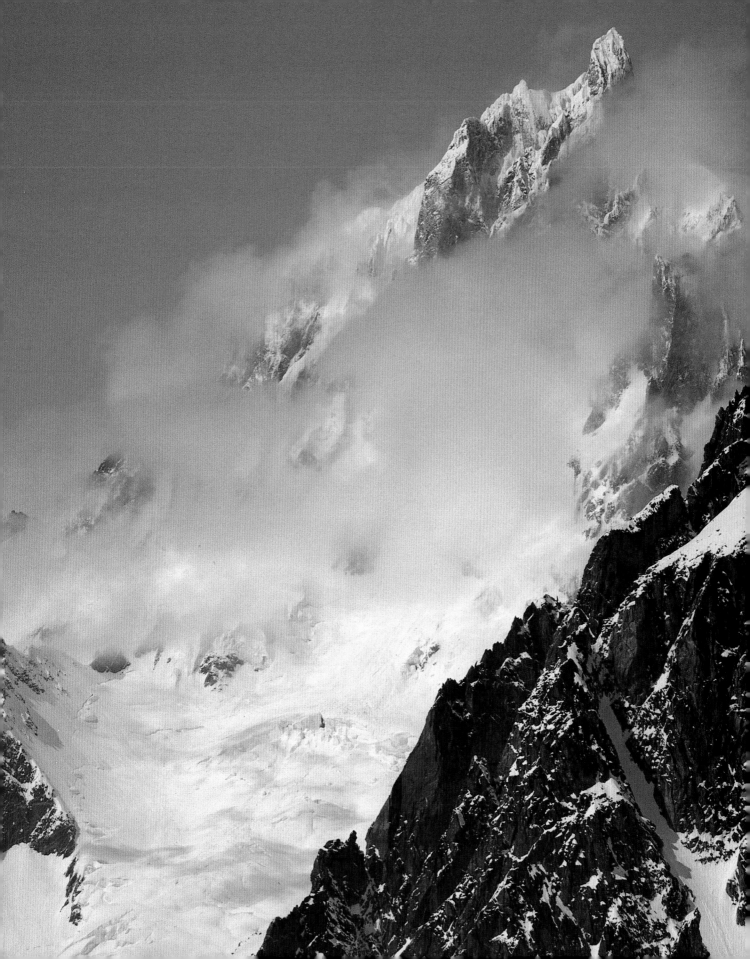

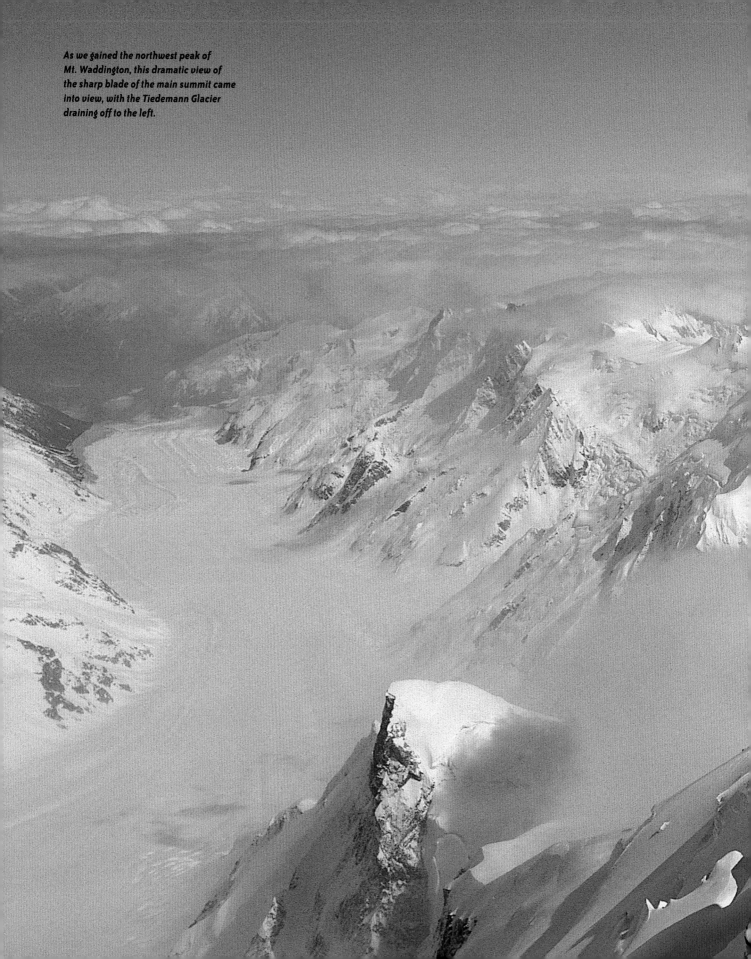

As we gained the northwest peak of Mt. Waddington, this dramatic view of the sharp blade of the main summit came into view, with the Tiedemann Glacier draining off to the left.

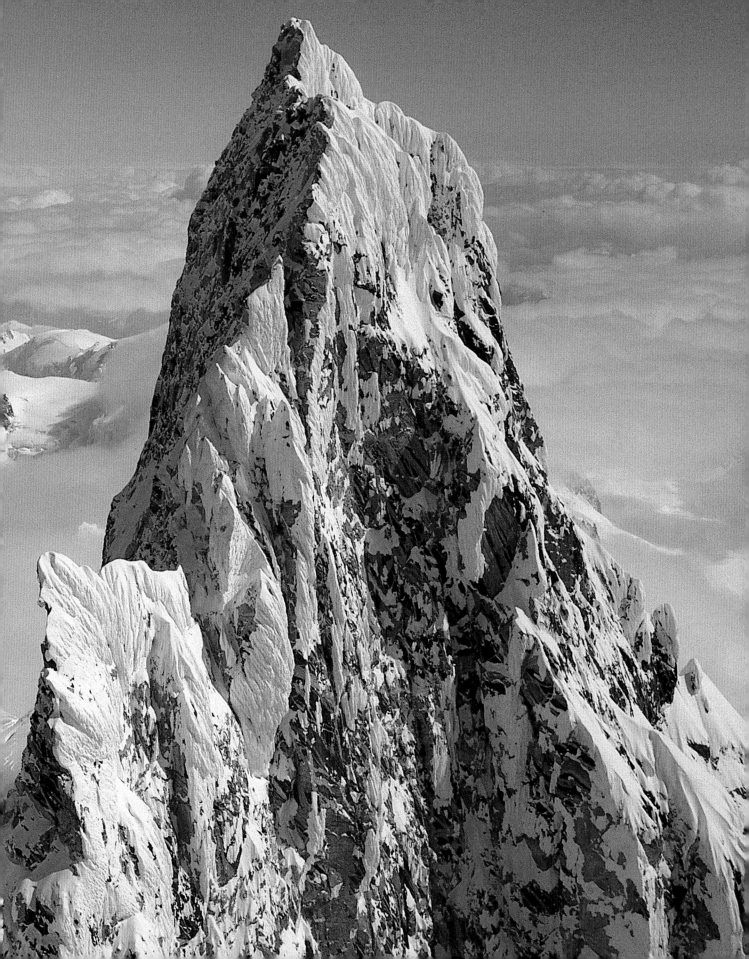

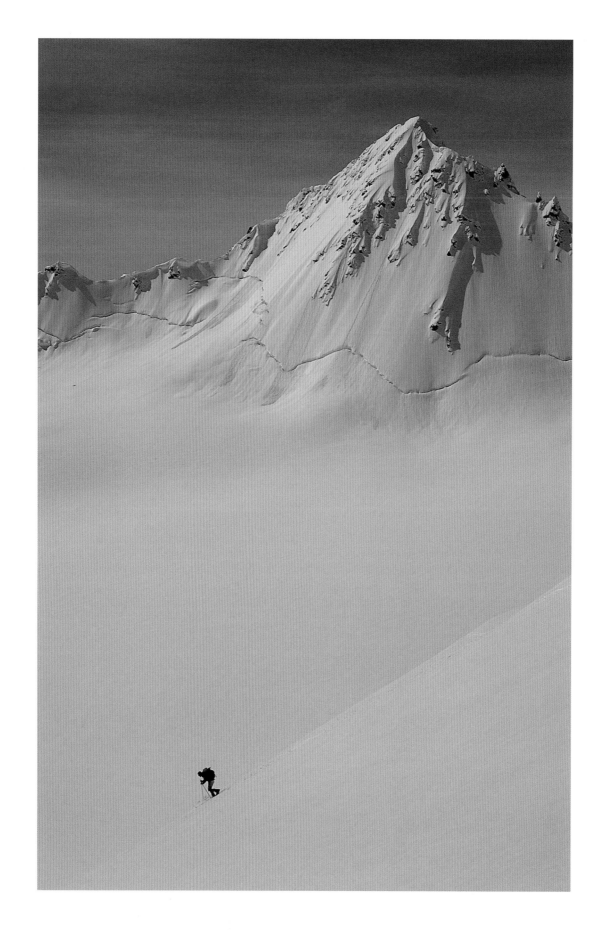

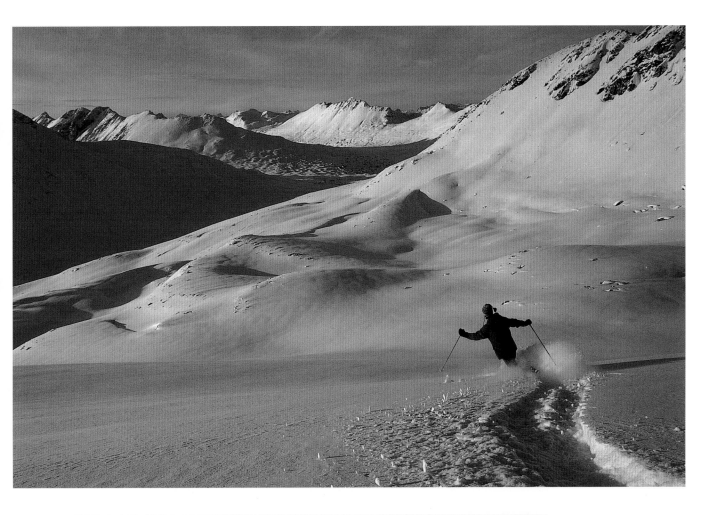

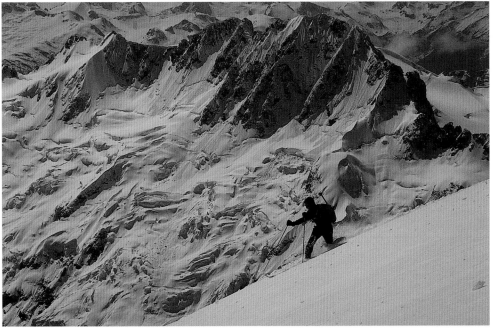

Opposite: Skiing is one of the real treats of winter and spring travel in the high alpine. Dave Williams links telemark turns in perfect corn snow on this south-facing slope on the Juneau Icefield.

Above: Eda Kadar carves turns through the dry winter snow in the Chilcotin Ranges.

Left: George Fulton skis off Ogre Mountain on the Monarch Icefield.

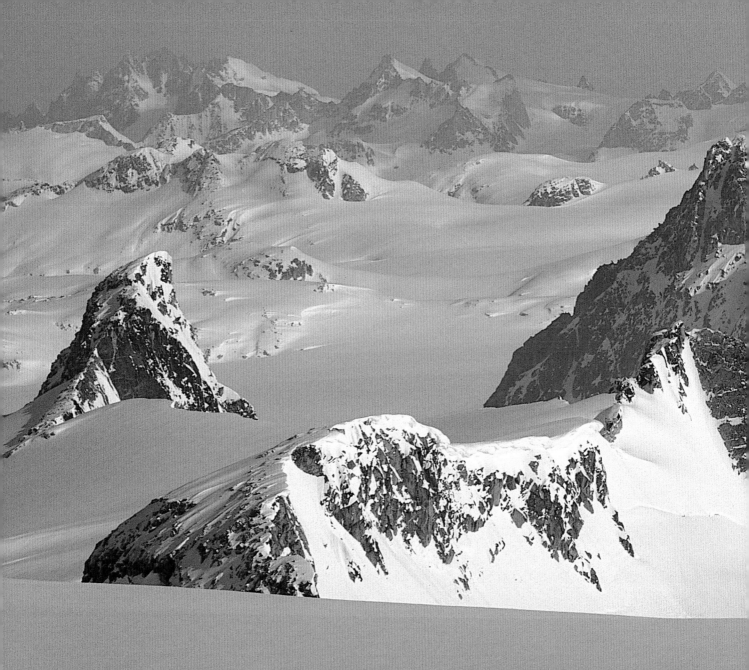

A skier meanders across the
huge expanse of the Homathko
Icefield.

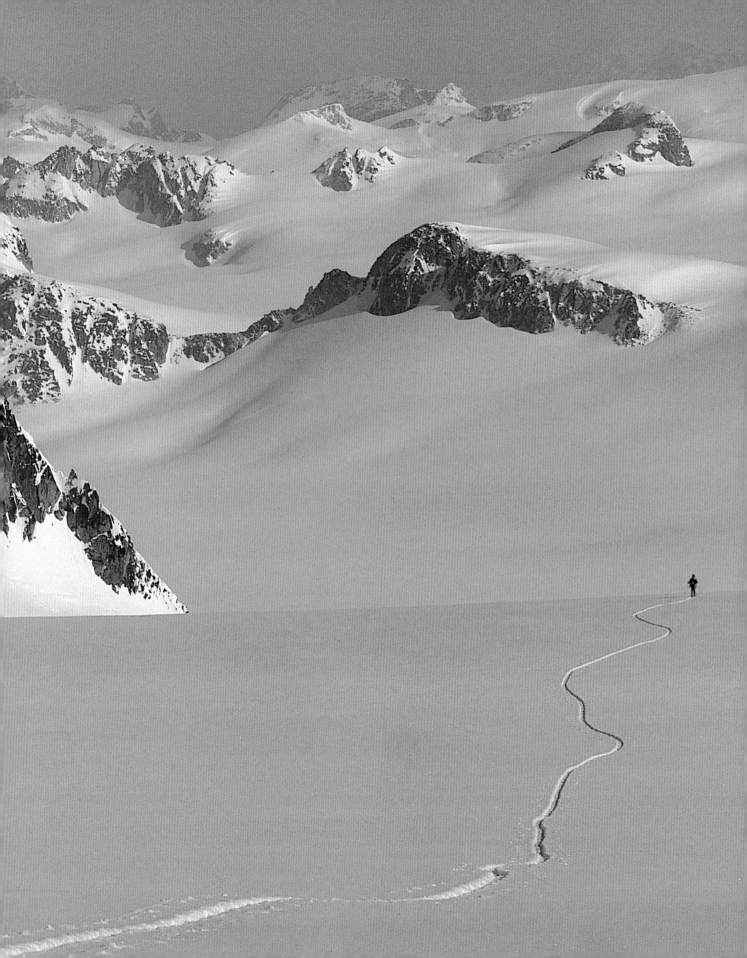

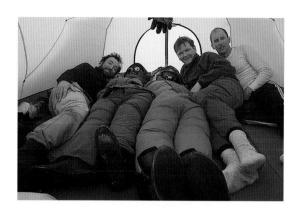

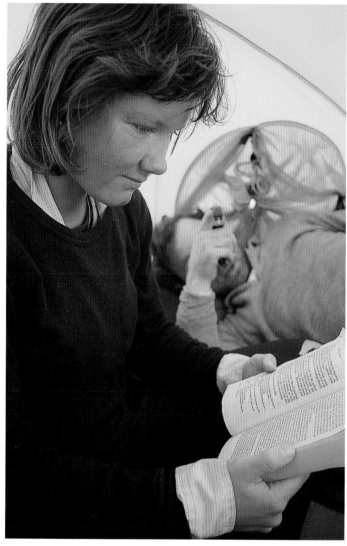

Skiers while away the hours and days during long periods of stormy weather as the icefields become impassable in thick fog or snow.

Above right: Helen Sovdat reads and Steve Ludwig plays a game on his wristwatch.

Top: This stir-crazy trio have created new tent-mates.

Above: On several occasions, small striped warblers lost in a snowstorm landed near our tent.

Snow conditions on a spring trip can vary all the way from a hard, icy crust in the morning to mushy corn snow in the afternoon. But it is also common at higher elevations to find good powder skiing on north-facing slopes. It is a real treat to swoop off a summit onto a wide open glacial bowl and lay down the only set of ski tracks within a hundred kilometres. On these effortless downhill runs, one appreciates how well skis are suited to these icefields, especially on the long, gentle valley glaciers, where it is sometimes possible to coast 10 or 15 kilometres.

After several days of good weather the slow arrival of a storm is marked by a dark grey sky as waves of cloud surge in from the Pacific Ocean. The bright colours of sunny weather are replaced by shades of grey and the distant peaks take on a surreal quality. This endless grey is interrupted only by the pale blue scars of crevasses and patches of bare ice. As the sky thickens we are literally absorbed in the clouds until we can see not much more than our ski tips. Good weather is crucial to travelling in this icy landscape, as the icefields become impassable in thick fog or snow. Storms can last anywhere from one or two days to a week and must be waited out from the relative comfort of sleeping bags and tent. To provide essential shelter, we build a wall

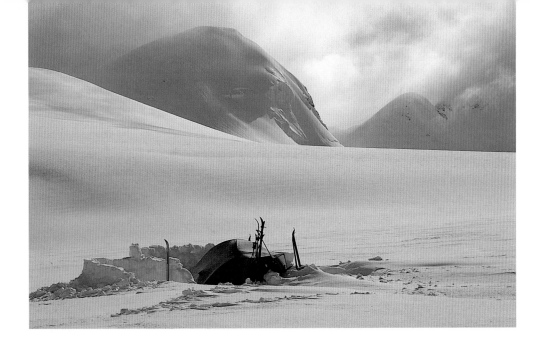

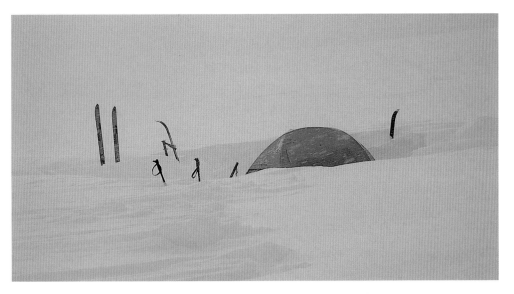

Top: On most camps such as this one on the Monarch Icefield, we build a protective wall of snow blocks to shield the tent from heavy winds during a storm.

Bottom: Our tent was almost completely buried after nearly a metre of snow fell during a three-day snowstorm in May, at the head of the Pashleth Glacier on the Ha-iltzuk Icefield. When the photograph was taken, we had spent eight of the previous eleven days tent-bound, and it was still snowing!

of snow blocks around the tent. It snows, and the glacier begins to engulf us in its own patient way.

To many skiers and climbers these periods of forced bed rest are the hardest part of a long trip in the Coast Mountains. There is nothing like three days in a tent to get to know your companions! Some people catch up on lost sleep, some read. Stories are traded back and forth and there is time for fixing equipment. But it is also a time to relax. Over the past twenty-five years I have spent over a hundred days in a tent waiting out bad weather. Outside the snow is driven by the wind and sprays against the tent. All sense of time seems to slip away. There is nowhere to go and nothing to do except watch—just lie there and wait and watch. For twenty-four hours a day a small sleeping pad 50 by 180 centimetres is the only speck of comfort in the vast swirling storm. To keep from being buried, the tent must be shovelled out regularly. The heavy winter snowfalls are past, but it is not uncommon to receive over a metre of snow in a three-day storm. On one trip to the Machmell River area in 1984 we had over 3 metres of snowfall on a four-week trip in May.

Slowly, day by day, the wind shifts with the passing of the storm, until finally it stops snowing and a grey light dawns in the sky to the west, to be followed later by a shaft of sunlight. As we dig our way out of hiding the air is cold and fresh and our skis, which have been standing in the snow, are covered by feathers of ice. It is always a surprise at the end of a long storm to see that our buried tent provides the only reference point with which to mark the new snowfall. After the tent is taken down, the snowy landscape looks exactly as it did before the storm.

In this way we move little by little toward the coast as a game of cat and mouse develops between each break in the clouds. Our progress across the icefield resembles the sporadic motion of a pebble on the beach, which moves only when a large enough wave nudges it along. Roaming in the mist and the cloud, tasting the cool sweet evening air as it mixes with the last warmth of the evening sun on our cheeks, we become part of this place.

In addition to storms and poor weather, route finding is complicated by crevasses and

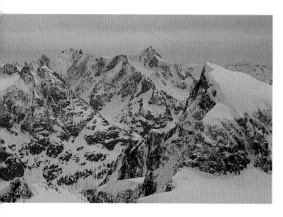

Above: After a storm the mountains take on a snow-plastered look, as in this view of Peter Stone atop a minor peak on the edge of the Monarch Icefield.

Right: Crevasses are cracks in the surface of a glacier, formed as it flows downhill, and they can be as deep as 30 metres.

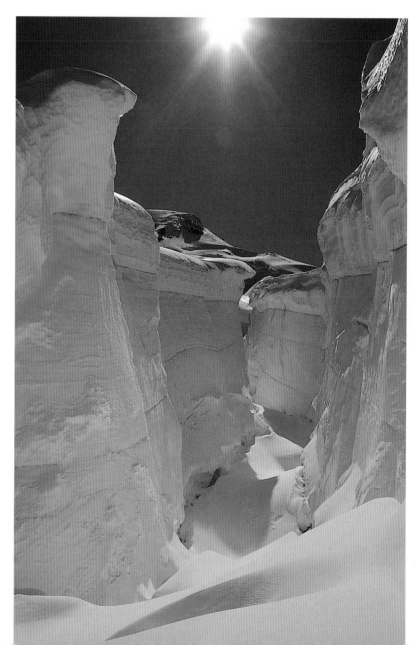

avalanche hazard. Crevasses are cracks in the surface of a glacier formed as it flows downhill, bending over drops and around corners. As these trips involve almost continuous skiing on glaciers, it is necessary to constantly be on the lookout for crevasses, some of which are 30 metres deep. Areas that are completely broken up into icefalls are easily avoided. Most dangerous to skiers are isolated crevasses that have been partially covered over by a thin snowfall. These can be recognized by a depression in the surface of the snow that runs along a crevasse. In many areas of the Coast Mountains the heavy snowfall builds thick snow bridges that are safe to cross on skis, but in some areas it is necessary to ski roped up to prevent an accidental fall into a crevasse. Avalanches are the most hazardous aspect of high mountain skiing, so it is necessary to be constantly on the lookout for any avalanche danger. This involves assessing snow conditions as well as the surrounding terrain for avalanche potential. However, avalanches are generally more predictable in spring and with careful route planning most steep slopes can be avoided.

A skier picks a route carefully through a set of partially buried crevasses.

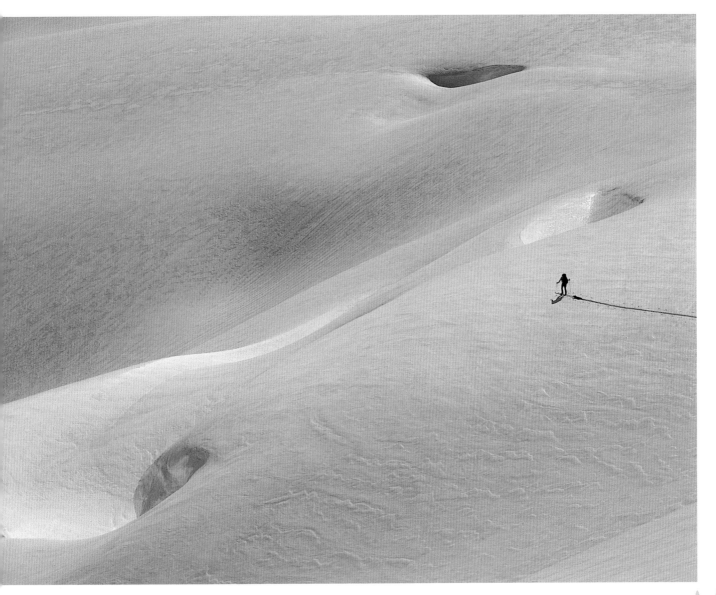

After crossing many of the icefields in the Pacific Ranges, using the familiar pattern of traversing across the width of the range, I did a trip in 1987 that followed the only portion of the southern Coast Mountains that actually forms a divide between interior and coastal drainages. This led through the mountains south of Chilko Lake and ran in the same direction as the main spine of the Coast Mountains. This shift in direction served to trigger the idea of linking up several of the longer traverses, and it soon became apparent that it was possible to form a high-level ski route through the entire length of the Pacific Ranges from Bella Coola to the Fraser Valley. It is a spectacular route, almost entirely on glaciers, crossing half a dozen major icefields and dropping into valleys only three times, where the main divide of the Coast Mountains is severed by major rivers running through the range from the BC Interior. It is 400 kilometres long in a straight line, but is probably close to twice that on the ground, a distance too great to tackle in one go. It took me ten years, section by section, seventy-five days in total. Most of the sections were skied in May but some also in December and others in June. I skied the last leg of this high-level route in 1992.

Above: John Clarke enjoys coasting down a long, gentle branch of the Lillooet Glacier.

Map: Over a ten-year period I linked up sections of a ski traverse to form a high-level ski route through the entire length of the Pacific Ranges from Bella Coola to the Fraser Valley.

Opposite: A camp at the head of the Meade Glacier on the Juneau Icefield.

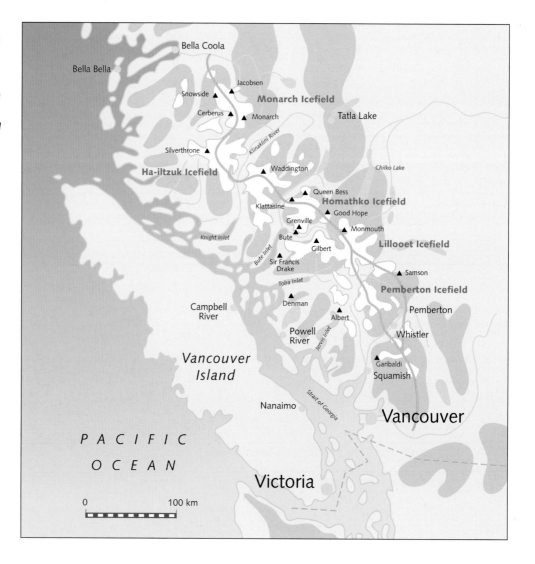

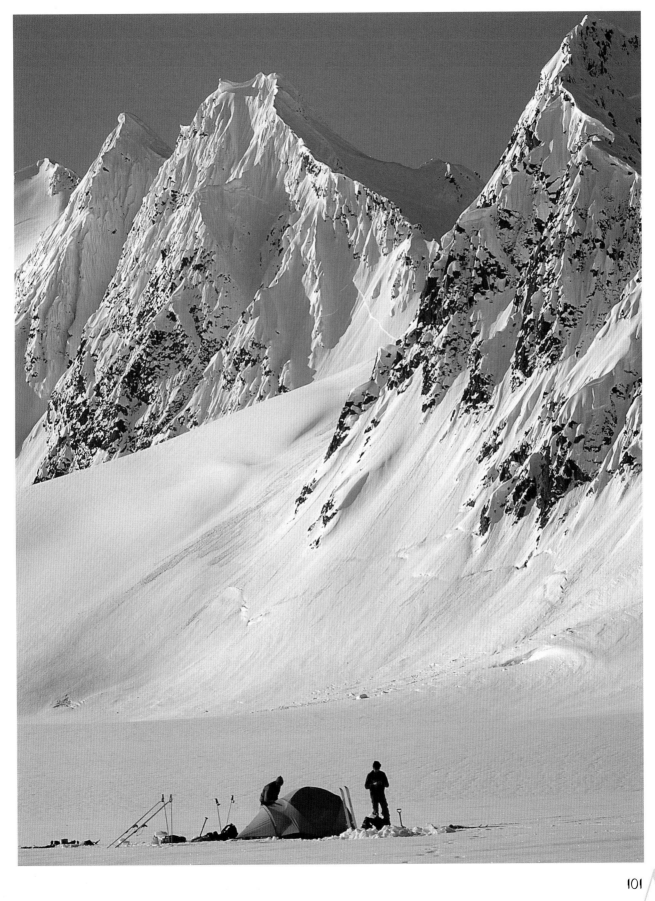

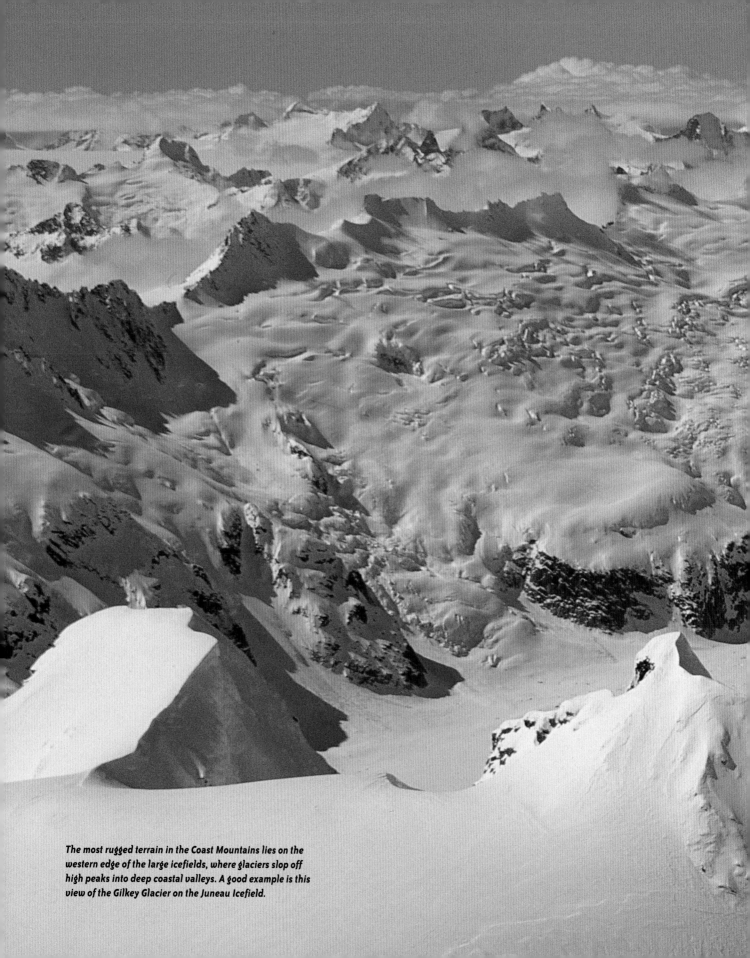

The most rugged terrain in the Coast Mountains lies on the western edge of the large icefields, where glaciers slop off high peaks into deep coastal valleys. A good example is this view of the Gilkey Glacier on the Juneau Icefield.

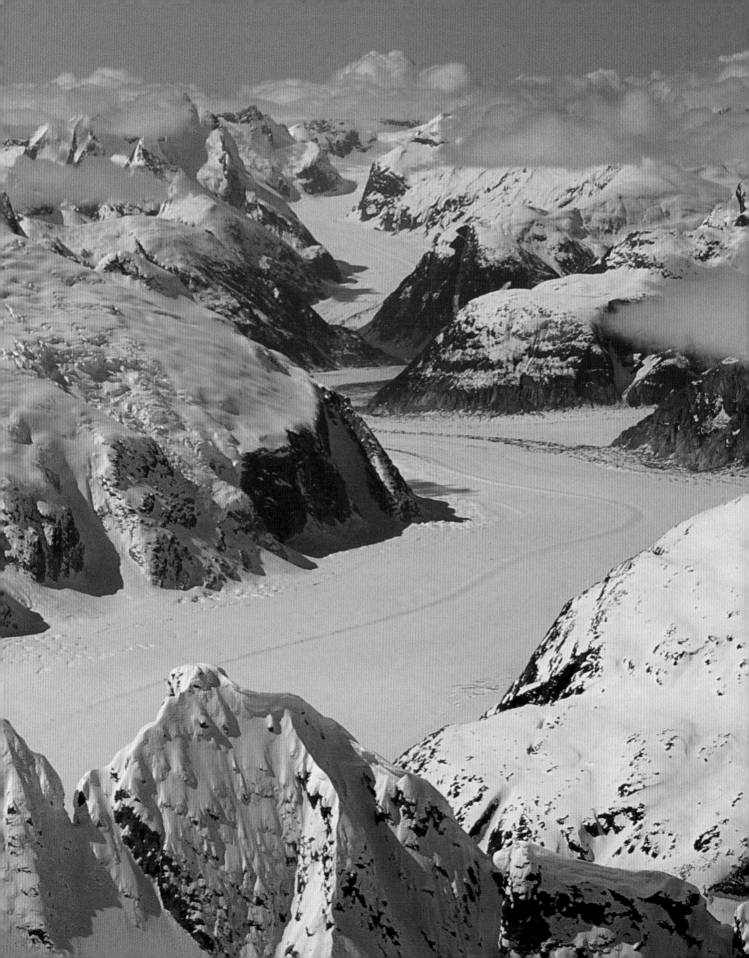

As we near the coast the large icefields come to an end, but in contrast to the interior side of the range, where the glaciers drain off gently to wide alpine valleys, the coastal side of the large icefields is startlingly abrupt. The glaciers tumble out of sight into the depths of wild remote valleys, and the thick smell of forest and sea comes rising up with air currents from below. The sounds of hooting grouse and running water muffled by distance signal the arrival of spring as we embark on the long drop to salt water. After weeks in the high icefields the first sight of trees begins to prepare us for our return from ice and snow, which we always find overwhelming. Lower down, the previous year's growth of ferns lies pressed and brown, accentuated here and there by the brilliant green of new shoots. The leafless stalks of devil's club bat at our packs. Numerous small streams trickle with lovely clear water and the sound of birds mingles with the warmth in the air. There is a calm feeling as the end of our journey draws near. The nearby barnacles seem a long way from those pine trees in the interior. The Coast Mountains take an hour to cross by plane, but the distance between the Chilcotin plateau and the tidal inlets we have reached takes on a different form when viewed from the ground. It can no longer be measured in kilometres or even days, but instead becomes a feeling of huge glaciers, mist and cloud and endless snow.

Our return to civilization begins with our arrival at one of the coastal logging camps. We always experience culture shock after a trip on the icefields—even talking to strangers requires readjusting! The biggest jolt comes after our flight out of the remote camp. The ordered world of roads, cars, subdivisions and shopping malls is overwhelming after several weeks in the land of year-round snow and ice.

We drop down onto a logging road above Knight Inlet after completing a ski traverse across the Waddington Range, on our way home.

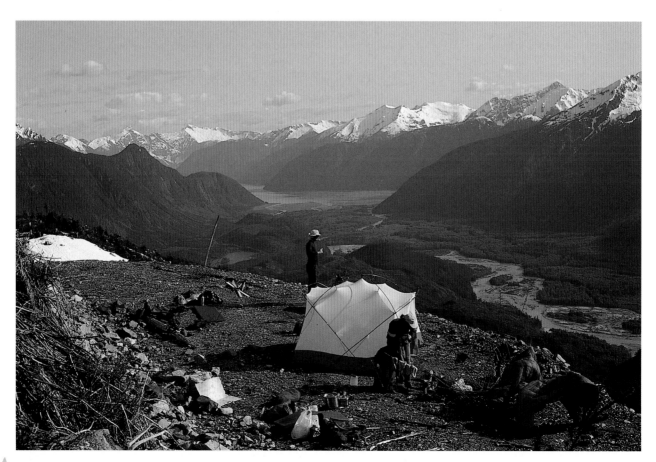

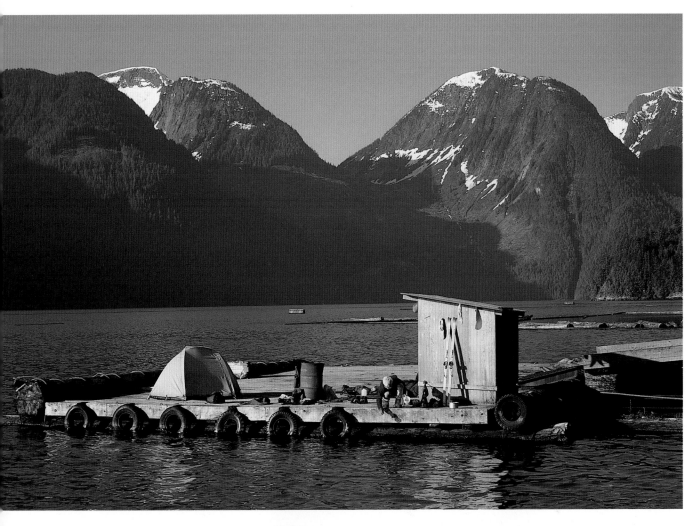

Above: Waiting for a float plane pick-up at the head of Toba Inlet.

Right: Dropping down into the coastal valleys at the end of a ski traverse is not always straightforward. Here, Gordon Ferguson struggles with a difficult exit from the Whitemantle Range.

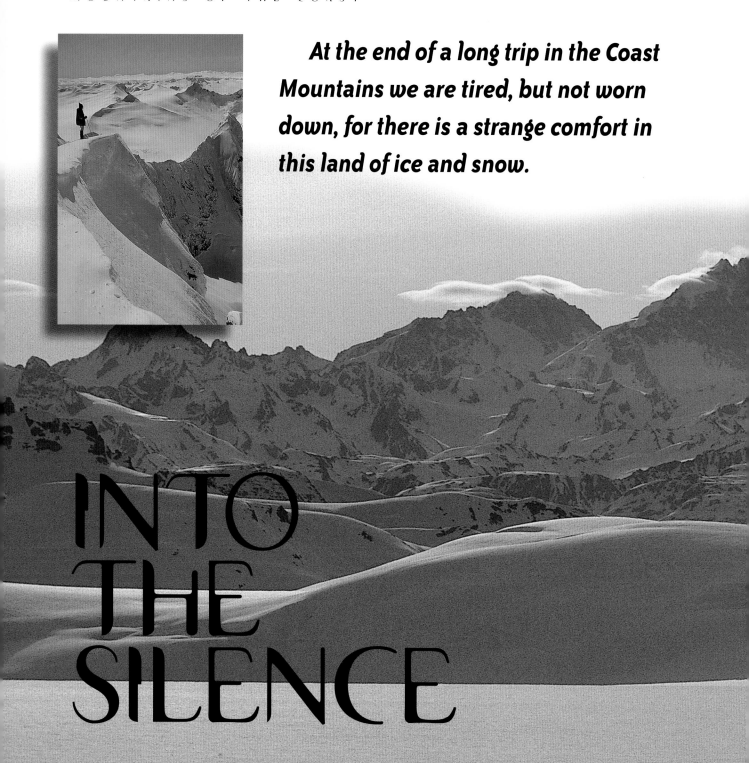

At the end of a long trip in the Coast Mountains we are tired, but not worn down, for there is a strange comfort in this land of ice and snow.

INTO THE SILENCE

In the public eye mountaineering has come to be seen as a death-defying sport in which the climber thrives on the adrenaline rush of living on the edge. But not all climbing is inherently dangerous or risky. While it is true that statistics for climbing in the Himalayas resemble those of going to war, the type of mountaineering described here is probably no more dangerous than driving a car. For most of us who drive regularly on the highway, it is easy to forget that a splitsecond lapse of attention can result in instant death.

Yet there is another side to climbing mountains. For me the pleasure of mountaineering is not the adrenaline rush and it is not the challenge of living on the edge. Over the years the greatest impetus for a trip has come to have less to do with accomplishing certain routes or first ascents, and more to do with the joy and excitement of visiting the high, wild and beautiful places that I have come to know so well. It is a simple, uncomplicated enjoyment of nature and its hidden treasures. It is the silence, the mist hanging over jagged peaks, the curves of snow slopes as they recede into the distance, the waterfalls coursing down mossy outcrops of rock.

Inset, opposite: Dave Williams surveys rugged peaks on the western edge of the Juneau Icefield.

Opposite: A weepy sky hangs over the Waddington Range, as seen from the Silverthrone Glacier.

Inset, below: Undulations in a snowslope create an abstract feel to the landscape this skier is travelling through.

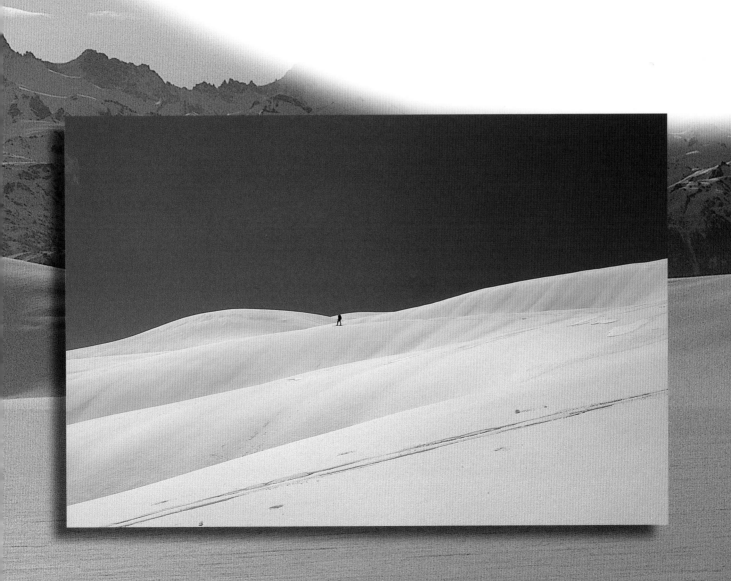

I remember reading an article a few years ago about a spectacular alpine climb in the remoter parts of Yosemite National Park in California. It wasn't the climb, however, that caught my attention; it was the author's excitement about walking through a short stretch of untracked forest to reach a trail. He was thrilled at seeing this tiny piece of wilderness, and I was shocked to realize how small and precious it was. The fact that I grew up at the foot of the Coast Mountains in British Columbia made it especially startling for me. Here, the mountains stretch for miles and miles without roads or trails and we take it for granted that mountains and wilderness are the same.

The fact that such an expanse of wilderness can exist so close to Canada's third largest city is attributable not to anyone's foresight but rather to the sheer ruggedness of this inhospitable terrain, as well as its lack of economic value. These mountains have remained a vast reservoir of wilderness: an enclave that escaped the onslaught of western civilization across North America. Along with areas in the far north, it is one of the last wild regions on this continent.

Throughout the history of mankind, wilderness has provided a place of solace and comfort, a place of spiritual renewal. Its timelessness and scale provide a perspective that restores a sense of balance and completeness to us as we live our busy lives. Lying on the mossy floor of the forest, swimming in alpine pools and climbing high onto icefields we have come to feel a part of this place. There is a searing beauty here that lives in the rocks and ice, the patterns of snow, the shades of mist and the breath of wind and softly, with the patience of a small stream carving a great canyon, it speaks to our souls. It speaks not in words but in whispers. No one is quite sure what it whispers but drawn to the shores of a great silence we sit looking, breathlessly, lifting up barnacle-covered rocks to see what's under them.

Below: Gordon Ferguson and Dave Sarkany pause for a snack in the Pantheon Range.

Opposite: Marine cloud trapped behind a shoulder of Bute Mountain.

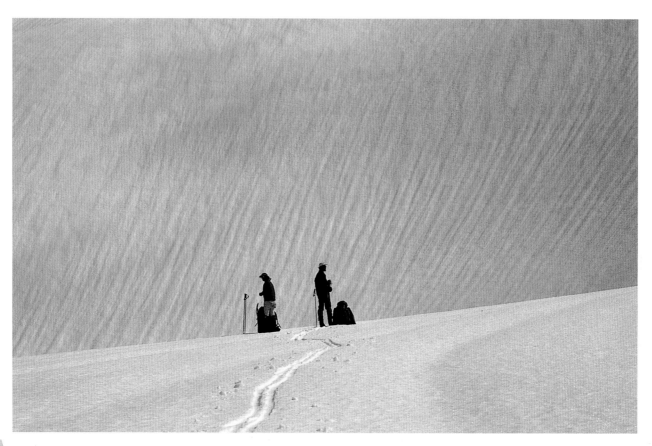

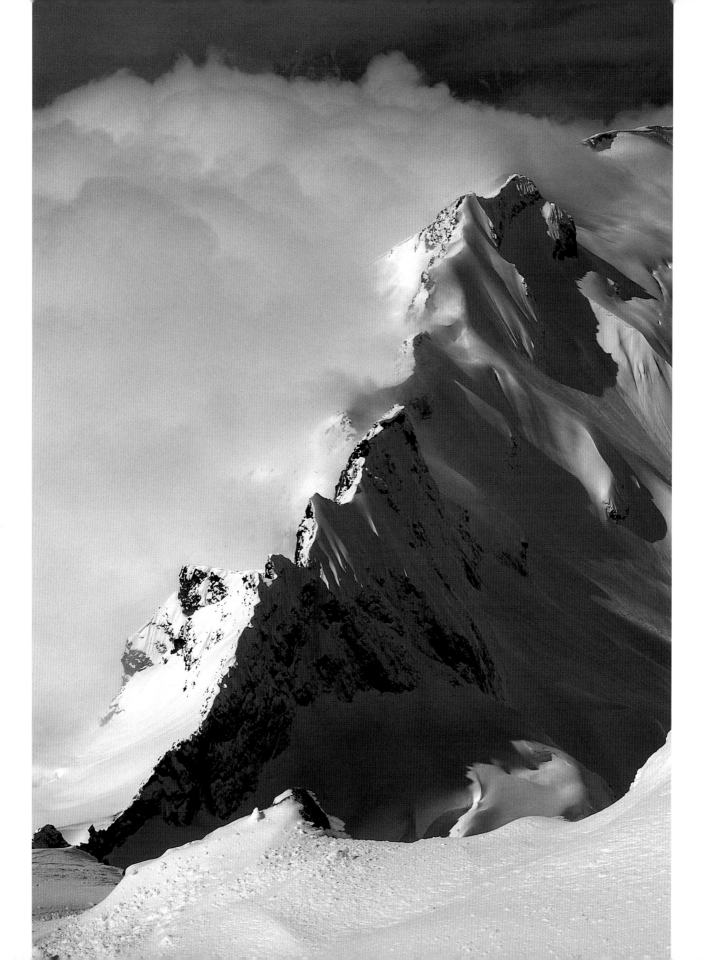

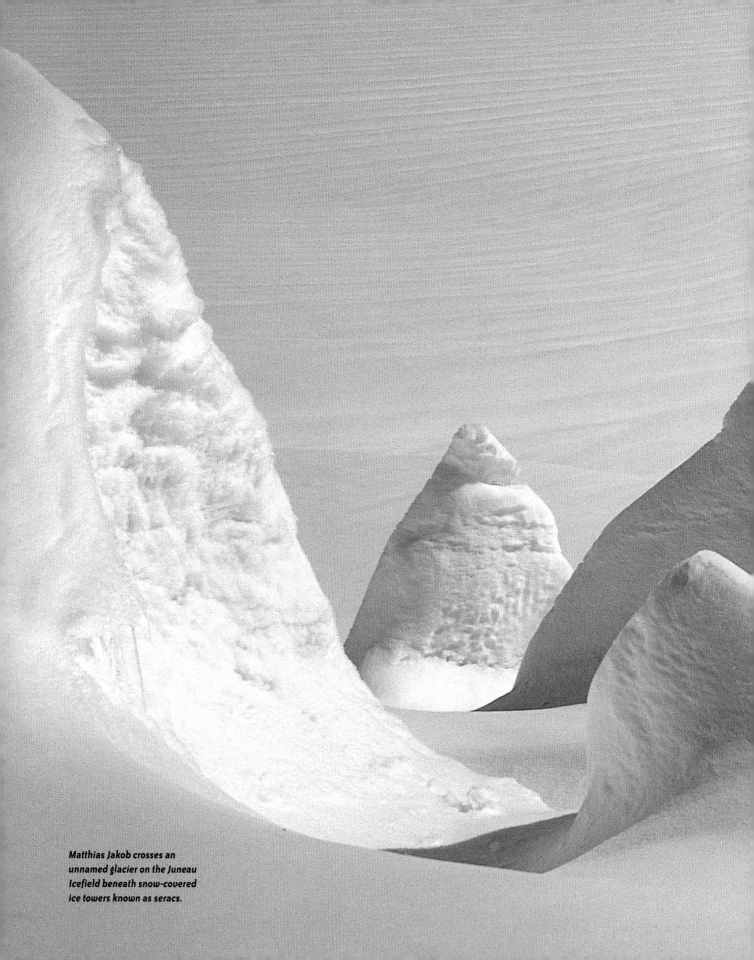

Matthias Jakob crosses an unnamed glacier on the Juneau Icefield beneath snow-covered ice towers known as seracs.

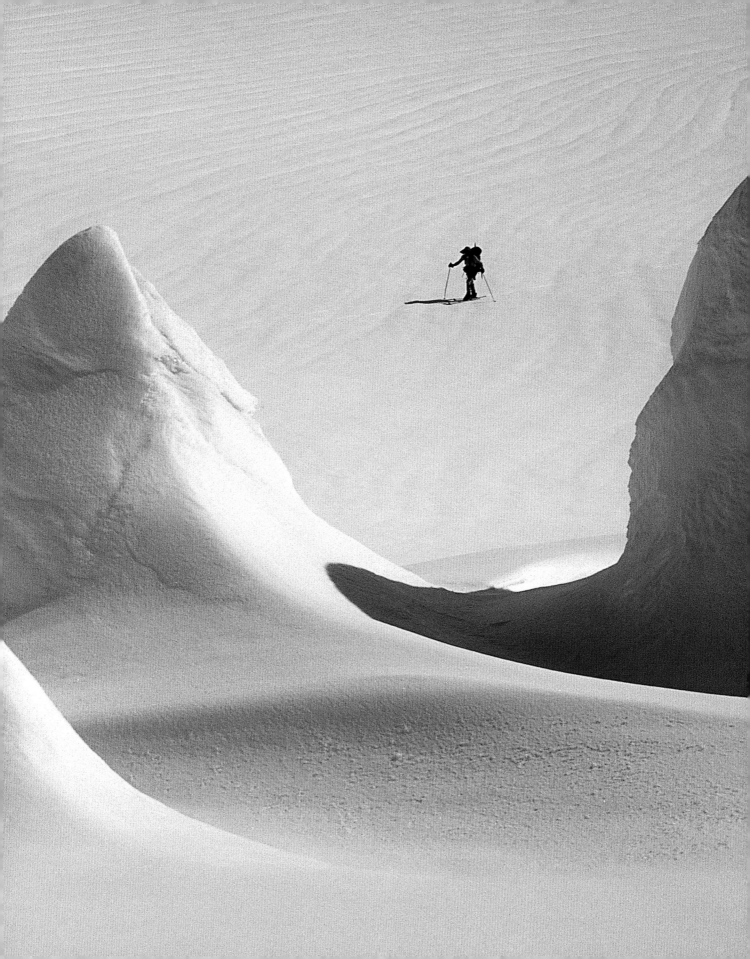

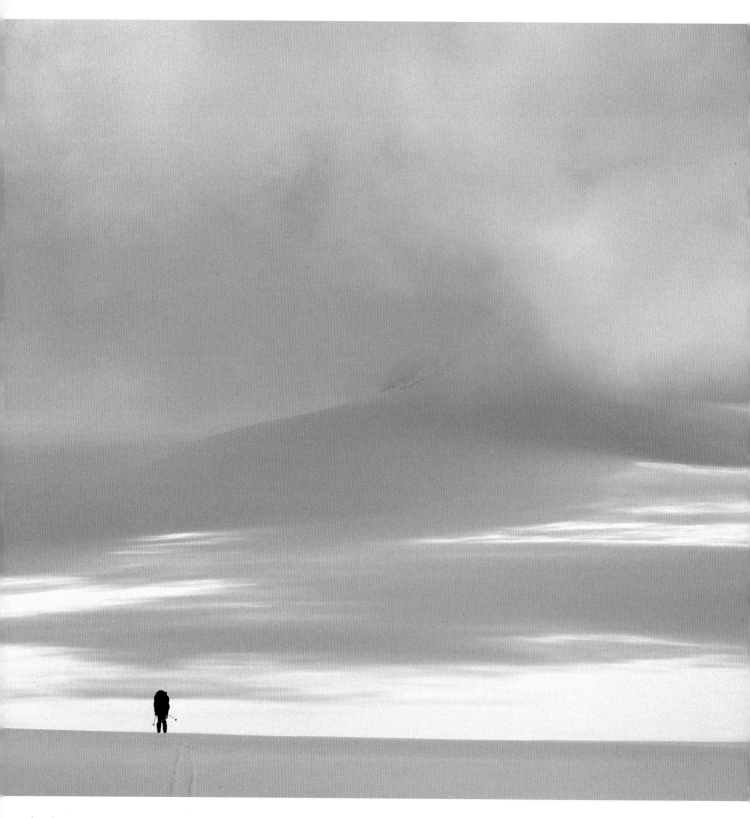

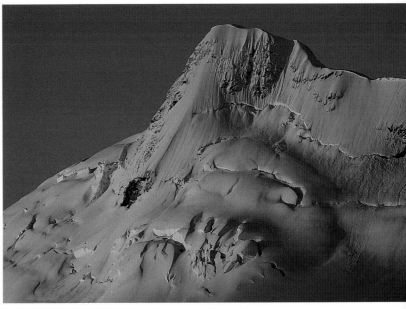

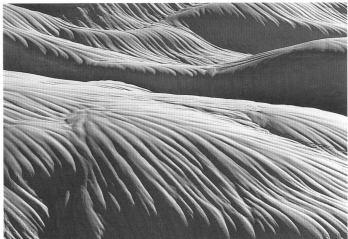

Opposite: John Clarke descends onto the wide expanse of the upper Lillooet Icefield. These open spaces are not unlike the prairies.

Top: Mt. Satan, on the Monarch Icefield.

Above: Drainage patterns in the snow on Mt. Seymour, caused by rain.

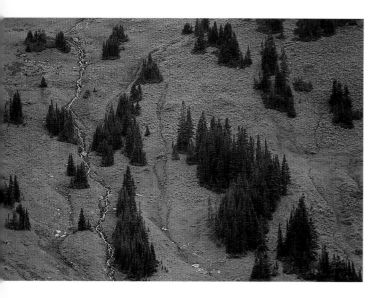

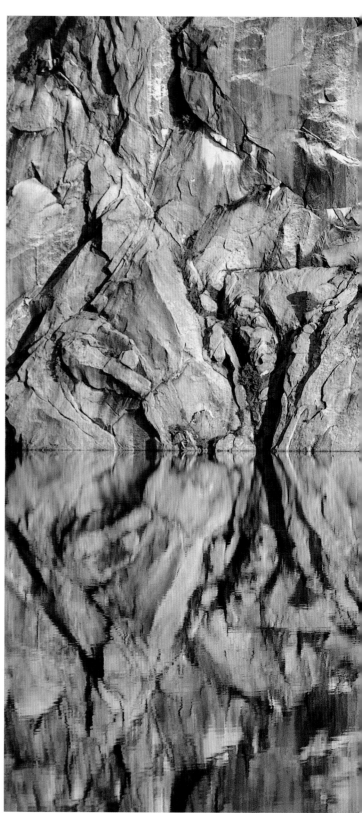

Summer in the mountains has its own beauty, seen here in the patterns of trees in the alpine (top), glacial scouring on a smooth rock slab (above) and reflections on a lake west of the Tahumming River (right).

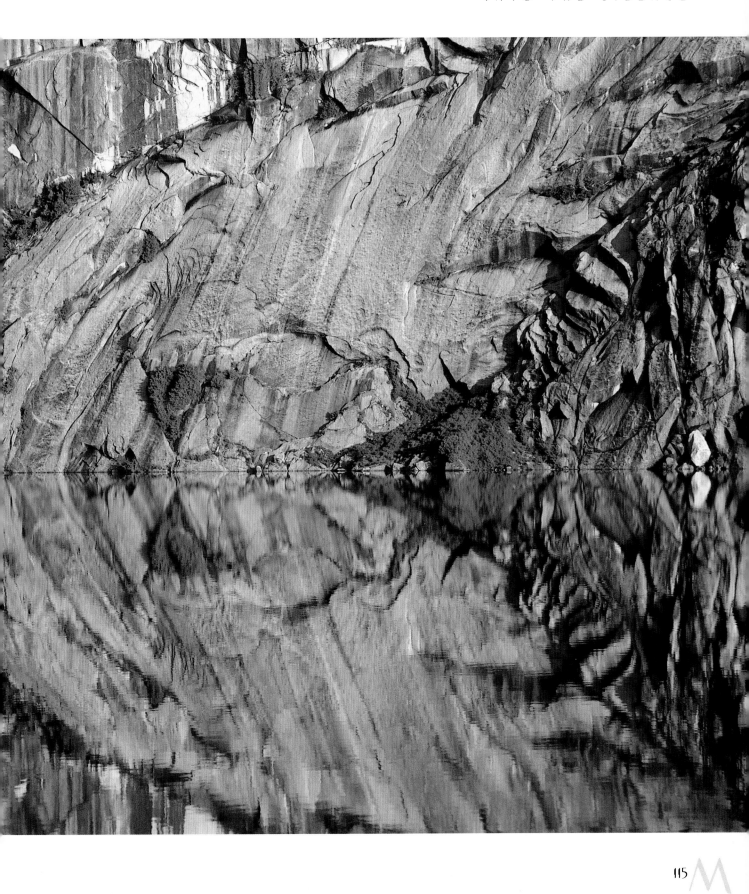

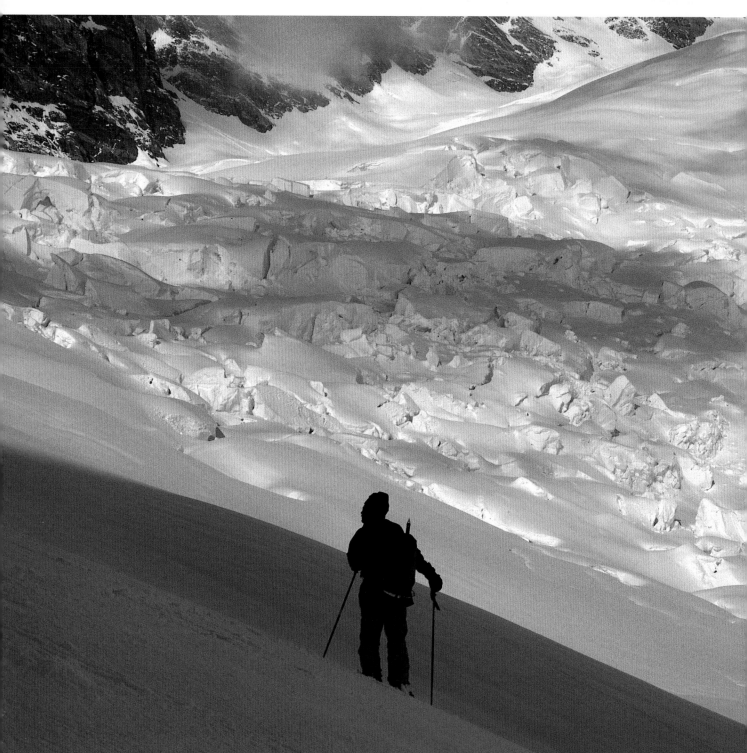

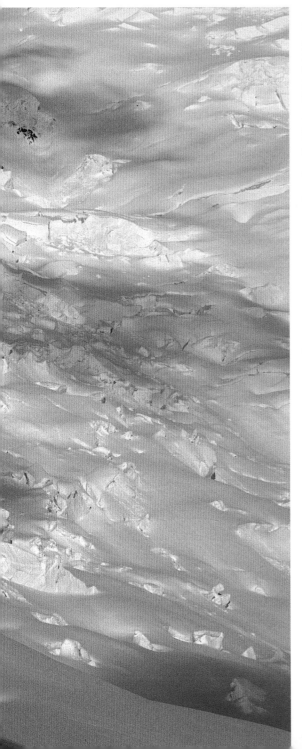

Opposite: Steve Ludwig below an icefall on the upper Dais Glacier.

Opposite, top: This abstract ripple pattern is actually suncups on the snow surface silhouetted against afternoon light.

Above: John Clarke peers into a misty cleft above the Klite River.

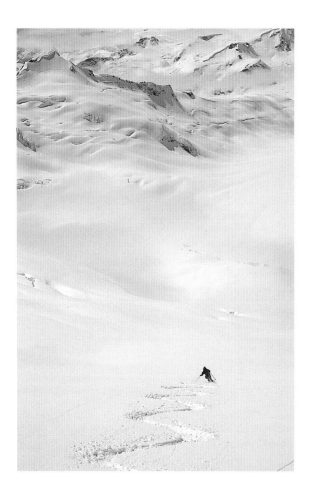

Above: Steve Ludwig takes an endless run on the Dais Glacier.

Right: Evening light casts a warm hue on wind patterns in the snow.

Published by
HARBOUR PUBLISHING
P.O. Box 219
Madeira Park, BC Canada
V0N 2H0

Cover design, maps, page design and composition by Roger Handling, Terra Firma Digital Arts
All photographs by the author unless credited otherwise
Printed and bound in China

Harbour Publishing acknowledges the financial support of the Government of Canada through the Book Publishing Industry Development Program (BPIDP) and the Canada Council for the Arts, and the Province of British Columbia through the British Columbia Arts Council, for its publishing activities.

THE CANADA COUNCIL | LE CONSEIL DES ARTS
FOR THE ARTS | DU CANADA
SINCE 1957 | DEPUIS 1957

Canadian Cataloguing in Publication Data

Baldwin, John Frederick, 1957-
 Mountains of the coast

 ISBN 1-55017-213-1

 1. Coast Mountains (B.C. and Alaska)—Pictorial works. I. Title.
FC3845.C56B34 1999 971.1'104'0222 C99-910910-3
F1089.C7B34 1999

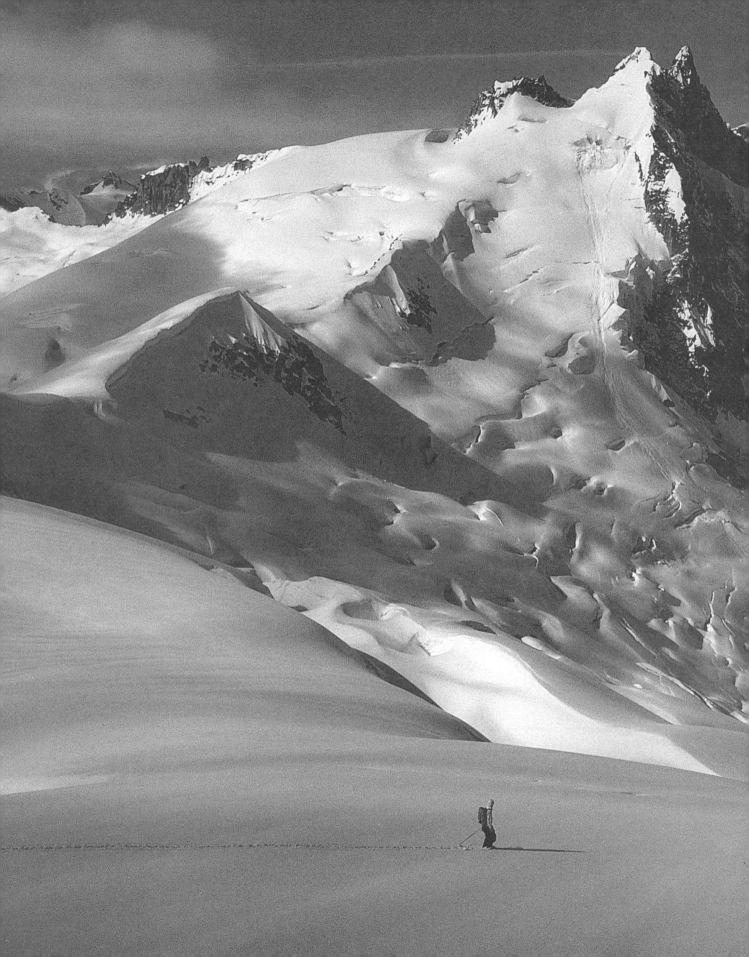